HotHouse

Expanding
the
Field
of
Fiber
at
Cranbrook

1970-2007

Cranbrook Academy of Art

Cranbrook Academy of Art Graduates of the Fiber Department, 1971–2007

1971
Haruno Iwashiro Arai MFA
Lee Clawson
Christine Oatman
Hiromi Oda (Non-degree Student)
Arturo Alonzo Sandoval
Janet Luks Siegel
Barbara J. Wittenberg
Betty Woolfolk

1972
Nancy Brett MFA
Nancy Fisher
Judith Millis Giacomo
Marilyn Leon
Sherril Keeler Moran
Sina Pearson
Karene Skarsten
Charlotte White

Anne Wilson BFA

1973
Susan Aaron-Taylor MFA
Audrey Daniels
Tetsuo Kusama
Tomoko Onishi
Phillip Warner

Robin Greeson BFA
Leonore Payne Jetley

1974
Gerald Bellas MFA
Cornelia Breitenbach
Carlos Cobos
Marlene Cox-Bishop
Edward S. Lambert
Joan Livingstone
Mary Jane Mazuchowski
Hai Sun Ouh
Warren Seelig
Dorothy Zeidman

1975
James Gilbert MFA
Deborah Kaufman
Leonard A. Moskowitz
Gail Rutter-VanSlyke
Nancy Sweet
Yawanit Thongpahusatcha

Valerie Dearing BFA

1976
Natalie Craig MFA
Lois Hadfield
John Hawthorne
Marsha Karr
Zenaide Reiss
Jann Rosen-Queralt
Becky Saiki

Sarah Vincent BFA

1977
Barbara Cooper MFA
Teliha Draheim
Barbara Jurgensen
Sonia Loomis
Wesley Mancini
Linda Schultz Milligan
Deanna Nemeth
Michael Olszewski
Ann Peters Wessman

1978
Caryl Kaiser Boeder MFA
R. Patrice Lier
Judith Nelson Minzel
Gary M. Patterson
Wenda Von Weise

1979
Claire Begheyn MFA
Charlene Bickel
Patricia Campbell
Howard Crouch
Barbara Geshwind
Layne Goldsmith
Mia Kodani
Jane Lackey
Pamela Markus
Judith Smith
Shigeko Spear

1980
Mollie Fletcher MFA
David Kaye
Jayn Thomas
Katarina Weslien

1981
Sandra Brownlee MFA
Deborah Carlson
Christina Fong
David Johnson
Geary Jones
Patricia Kinsella
Libby Kowalski
Joan Levinson
Daniel Wagner

1982
Lillian Kay Dawson MFA
Cynthia Farley
John Krynick
Nancy Metcalf
Laura Foster Nicholson
Kay Pentzien
Carole Anne Waller

1983
Diane Castellan MFA
Barbara Eckhardt
Patricia Frank-Yagerlener
Hiroshi Jashiki
Lisa Lockhart
Kay Lee Willens

1984
Lee Bale MFA
Johanna Evans
Michael Howell
Marketta Makinen
Fuyuko Matsubara
Ellen Roberts
Lucy Slivinski

1985
Rosemary Bathurst MFA
Carol Burns
Maria-Theresa Fernandes
Carmen Grier
Mary Anne Jordan
Kinnari Panikar
Ann Schumacher
Sheri Simons
John Skau

1986
Morgan Clifford MFA
Annet Couwenberg
Rhonda Cunha
Deborah First
Rebecca Hendrickson
Heidi Meyer
Ted Ramsay

1987
Christina Cassara MFA
Checefesky
Randal Crawford
Suzanna Frosch
Virginia Keyser
Emiko Nakano
Leslie Terzian Markoff
Koo Kyung Sook
Lian Verhoeven
Pamela Wiley

1988
JoAnn Giordano MFA
Chad Hagen
Anne Lindberg
Ad Jong Park
Susie Rubenstein
Piper Shepard
Mickey Spinale Cully

1989 Elizabeth Billings MFA
Nick Cave
Akemi Nakano Cohn
Gerry Craig
Jodi Johnston Haller
Marianne McCann
Evan Riter
Clare Verstegen
Bhakti Ziek

1990 Marcie Miller Gross MFA
Jaymes Leahy
Leena Saarto

1991 Chris Allen-Wickler MFA
Claudia Bielaczyc-Pollard
Barbara Moon Boertzel
Kyoung Ae Cho
Lyda Cort
Susan Doerr-Overmyer
Robben McAdam
Ólöf Nordal
Keith Romaine
Tal Saarony
Carrie Seid
Gyaeyoung Song

1992 Stacy Arestedes MFA
Janet Ecklebarger
Kristine Jaeger
Birgitta Lindberg
Andrea S. Wasserman

1993 Christina Bechstein MFA
Paula Stebbins Becker
Atsuko Fukui Chirikjian
Kristen Dettoni
Wen-Ying Huang
Lisa Lesniak
Kristen Miller
Erin Shie Palmer
Celeste Scopelites

1994 Lori Calentine MFA
Rita Grendze
Kate Humphrey
Suzanne Ragan Lentz
Jong Sook Moon
Laura Sansone

1995 Beth Blahut MFA
Sonya Clark
Theresa Ducayet
Cayewah Easley
Rebecca Hart
Geon-Man Lee
Nicole Nagel-Gogolak
Michelle Piano
Judi Ross

1996 Brett Bennett MFA
Nazanin Hedayat
Andrea Petrini
Joan Silver
Vernal Bogren Swift

1997 Lauren Gregerson-Brown MFA
Harry Guild
Gabrielle L. Kanter
Hyuk Kwon
Doris Louie
Jill Stoll
Seth Winner

1998 Daina Blackstone MFA
Mi-Kyoung Lee
Erin Miller
Marie Oberkirsch
Emily Roz
Kaori Takami

1999 Jessica Kincaid MFA
Jeanette Puig-Pey
Lori Tampa
Sheila Walker
Sarah Wiideman

2000 Robyn Dunbar MFA
Leesa Haapapuro
Conrad Hamather
Kelli Phariss
Helen Quinn
Andrea Rosenberger
Mary Stechschulte

2001 Jennifer Adams MFA
Deborah Fisher
Meredith Hamm
Vanessa Kamp
Bora Kim
Maryann Lipaj
Eeko Oniki
Song Hee Son

2002 Thomas Jacobs MFA
Sarah Kabot
Wook Kim
Honor Robie
Margaret Russell
Liz Sargent

2003 Lynn Bennett Carpenter MFA
Chris Churchill
Julie Custer
Shannon Kirby
Jeannie Mooney
Jeremy Noonan
Marie Wohadlo

2004 Brenna Burns MFA
Surabhi Ghosh
Amelia Symes-Gralewski
Amy Kaplan
Rachel Miller
Samantha Randall

2005 Mira Burack MFA
Marie Gardeski
Emily Keown
Andrea Gaydos Landau
Alison Miller
Sarah Nawrocki
Abigail Anne Newbold
Jennifer Pellman
Rowland Ricketts, III
Anne Selden

2006 Ruby Amanze MFA
Trisha Brookbank
Christina P. Day
Alison Greene
Lauren Rossi
SoYeon Yang

2007 Mara Baker MFA
Jung Yeon Choi
Lauren Jacobs
Sabrina Lee
Won Kyoung Lee
Emilee Lord
Courtney Mandryk
Abbie Miller
Jaya Denise Miller
Nancy Josephine
 VanDevender

From 1971 through 2007, there have been 275 graduates of the Fiber Department, including one non-degree student who fulfilled all requirements of the Master of Fine Arts (MFA) program. All graduates from 1977 through 2007 received an MFA degree. Prior to 1977, Cranbrook Academy of Art conferred both Bachelor of Fine Arts (BFA) and MFA degrees.

Credits and Sponsors

Hot House: Expanding the Field of Fiber at Cranbrook, 1970 – 2007 documents an exhibition presented at Cranbrook Art Museum June 17 through October 14, 2007. A Web-based component of the exhibition, representing the work of more than 150 graduates of Cranbrook Academy of Art's Fiber Department, is accessible at www.cranbrookart.edu/hothouse/. Hot House was complemented by the exhibition Material Memory: World Textiles from the Collections of Cranbrook Art Museum and Gerhardt Knodel also presented at Cranbrook June 17 through December 30, 2007.

Project Director: Gregory Wittkopp
Hot House Curators: Brian Young and Gregory Wittkopp
Material Memory Curators: Gerhardt Knodel and Rebecca Elliot
Exhibition Registrar: Roberta Frey Gilboe
Exhibition Preparators: Abigail Newbold with Jason Carter
Hot House Exhibition Design Consultants: Gerhardt Knodel and Jane Lackey
Exhibition Educators: Elena Ivanova with Vanessa Lucero Mazei
Hot House Web site: Mira Burack and Bethany Shorb
Project Assistant: Denise Collier

Catalogue Managing Editor: Gregory Wittkopp
Essays and Curatorial Statements Editor: Dora Apel
Artists at Work Photo Editor: Judy Dyki
Copy Editor: Judy Dyki
Catalogue Designer: Lucille Tenazas (CAA MFA in Design, 1981), Tenazas Design, New York, New York
Catalogue Typeset in News Gothic, Cachet, Futura, Univers and Rockwell
Catalogue Printer: University Lithoprinters, Ann Arbor, Michigan

Cranbrook Art Museum
39221 Woodward Avenue
P.O. Box 801
Bloomfield Hills, Michigan 48303-0801
248-645-3323
www.cranbrook.edu
www.cranbrookart.edu/hothouse/

ISBN 0-9668577-6-3

The exhibition and catalogue Hot House: Expanding the Field of Fiber at Cranbrook, 1970 – 2007 is generously sponsored through a gift from Marlin and Ginger Miller.

Additional support for the Hot House exhibition and catalogue is provided by Crypton Fabrics, West Bloomfield, Michigan. Cranbrook Art Museum's 2006-2007 Exhibition Season, including Hot House, is sponsored by LaSalle Bank.

Cranbrook Art Museum's 2006-2007 Exhibition Season and Education Programs are made possible, in part, by the Museum Committee of Cranbrook Art Museum; ArtMembers@Cranbrook, the Art Museum's membership group; and the Michigan Council for Arts and Cultural Affairs.

Cranbrook Art Museum is a non-profit contemporary art museum and an integral part of Cranbrook Academy of Art, a community of artists-in-residence and graduate students in art, architecture and design. Cranbrook Academy of Art and Art Museum are a part of Cranbrook Educational Community, which also includes Cranbrook's Institute of Science, Schools and other affiliated cultural and educational programs.

The Cranbrook signature is a registered trademark of Cranbrook Educational Community.

CRANBROOK

Table of Contents

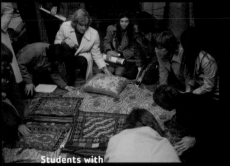
Students with
Gerhardt Knodel at Bud Holland's
Antique Textiles Gallery, Chicago

Into the Woods,
Cranbrook Campus, 1973

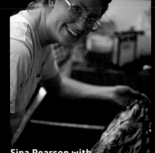
Sina Pearson with
Batik in Process

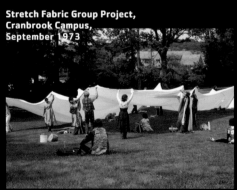
Meditation Chamber and
Susan Aaron-Taylor

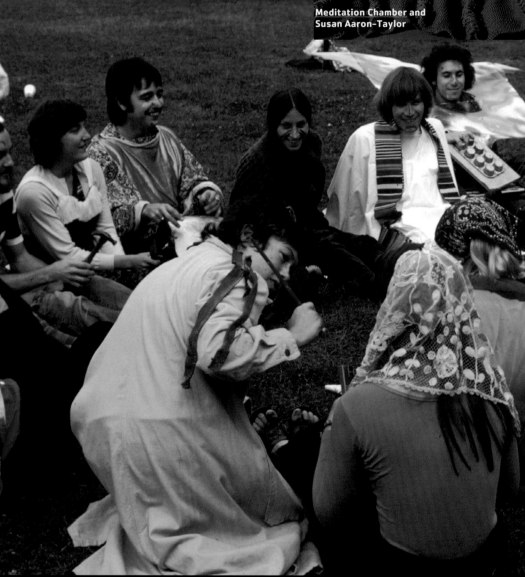

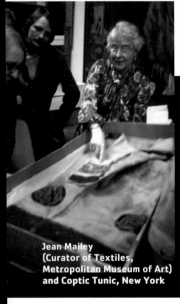
Jean Mailey
(Curator of Textiles,
Metropolitan Museum of Art)
and Coptic Tunic, New York

Stretch Fabric Group Project,
Cranbrook Campus,
September 1973

Mylar Workshop, 1971

Daffodil Hill,
Cranbrook House,
May 1971

6

Students at a Frank Lloyd Wright House, Oak Park, Illinois, 1972

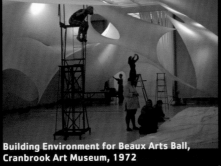

Building Environment for Beaux Arts Ball, Cranbrook Art Museum, 1972

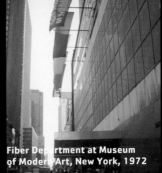

Fiber Department at Museum of Modern Art, New York, 1972

Deliberate Entanglements Exhibition, Chicago, 1972

1970-1975

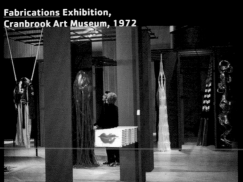

Fabrications Exhibition, Cranbrook Art Museum, 1972

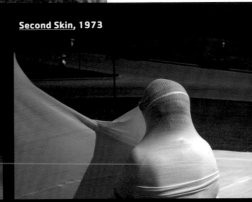

Second Skin, 1973

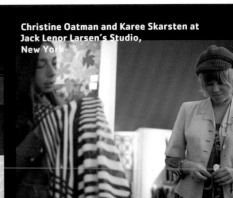

Christine Oatman and Karee Skarsten at Jack Lenor Larsen's Studio, New York

Tending The Hot House

Cranbrook Academy of Art has been a hothouse environment for graduate studies in the visual arts for more than seventy-five years. In particular, the program in fiber under the successive leadership of Gerhardt Knodel and Jane Lackey has contributed to the rethinking of the field, redefining and shifting it in new directions. *Hot House: Expanding the Field of Fiber at Cranbrook, 1970-2007* presents work by Knodel and Lackey as well as sixty-eight of their 275 graduates, all of whom have contributed to the ever-expanding field of fiber.

Perhaps some definitions are in order. A hothouse —or in our more expansive form, "hot house"— is a glass structure kept artificially heated for the growth of plants. The origins of "academy" go back to the philosophical school of Plato in ancient Greece, and more specifically the garden near Athens where he taught. An academy is distinguished from a university as a place that emphasizes training in some specialized form of knowledge and skill. A northern clime version of Plato's garden, Cranbrook Academy of Art —where inquiry and personal growth are accelerated during a two-year program of study— is proud to present the flowering of its former students over the course of thirty-seven years.

Since Loja Saarinen established a weaving program at Cranbrook in the late-1920s as part of the original Arts and Crafts Studios, there have been just six artists who have tended this hot house and served as the Fiber Department's head: Loja Saarinen, Marianne Strengell,

Glen Kaufman, Robert Kidd, Gerhardt Knodel, and Jane Lackey. Their work at Cranbrook has shaped this evolving discipline as its focus has shifted from a weaving-based department building upon the tradition of the Arts and Crafts Movement to its present position as a material studies program grounded in contemporary fine arts practices.

Although Cranbrook Academy of Art prides itself on the work of the graduates of all ten departments, the accomplishments of the alumni of the Fiber Department during the past four decades since Knodel's arrival in 1970 are particularly impressive. Through their studio practices and leadership positions at colleges and universities in the United States and abroad, they have cultivated new generations of artists and designers and set the standards for the field.

The *Hot House* exhibition ideally would have included the work of all 275 graduates, as they all deserve recognition. Limited space in the Art Museum's galleries, however, necessitated some difficult decisions. After requesting images of current work from all the graduates, it was the job of Art Museum Curator Brian Young and me to select the artists and work for the exhibition. Our goal was to present a representative cross-section of all thirty-seven years that Knodel or Lackey headed the department, as well as the different modes of production and conceptual perspectives that define the field of fiber today. We chose to include both fine art and commercial

Cranbrook Academy of Art
Artists-in-Residence and Heads of the Fiber Department

Department of Weaving and Textile Design
Loja Saarinen (1929–1942; also directed Studio Loja Saarinen, 1928–1942)
Marianne Strengell (1942–1961)

Department of Weaving
Glen Kaufman (Instructor, 1961–1967)

Department of Fabric Design
Robert Kidd (1968–1970)

Department of Fiber
Gerhardt Knodel (September 1970–May 1996)
 Phillip Warner (Leave-of-Absence Replacement, January–May 1976) with Alexsandra Kasuba
 Joan Livingstone (Sabbatical and Leave-of-Absence Replacement, September 1980–May 1982)
 Harry Boom (Leave-of-Absence Replacement, January–May 1985)
 Margo Mensing (Acting Artist-in-Residence and Head, September 1996–May 1997)
Jane Lackey (September 1997–May 2007)
 Anne Lindberg (Sabbatical Replacement, January–May 2005)
Mark Newport (Begins September 2007)

studio practices, but decided to limit our selections to artists that have remained active within the field of fiber (realizing that we would be excluding the artists that have shifted their practice to fields such as painting). The *Hot House* Web site, however, includes the work of all the graduates that responded to our initial request for images and, in many respects, is the ideal exhibition that we could not realize in the Art Museum.

Producing an exhibition, catalogue and Web site that survey the work of over seventy artists is an enormous undertaking that depended on the hard work of numerous people, most of whom are listed with the "Credits and Sponsors" at the beginning of the catalogue. In addition to extending a warm and heartfelt thank you to all of them, as well as the sixty-eight graduates of the Fiber Department who graciously loaned their work to the Art Museum, there are a few people that must be mentioned individually. First and foremost, I thank Marlin and Ginger Miller whose extremely generous sponsorship allowed us to realize the exhibition and catalogue at a level of quality that matched our ambitions. At the Art Museum, I would like to single out Brian Young who had the daunting task of communicating on a daily and, at times, hourly basis with the seventy-plus artists in the exhibition; Registrar Roberta Frey Gilboe who, among other responsibilities, oversaw the transportation of the artists' work to Cranbrook from literally every corner of the globe; Preparator Abigail Newbold whose exhaustive efforts insured that all of the work looked its best installed in the galleries; and

our outgoing Jeanne and Ralph Graham Collections Fellow Rebecca Elliot whose passion for the objects in our collection, in this case our historic textiles, resulted in her second major exhibition demonstrating their relevance to contemporary audiences. Elsewhere at Cranbrook, I thank Cranbrook Archives Collections Fellow Mira Burack and Academy Web Coordinator Bethany Shorb for realizing the virtual *Hot House* exhibition on our Web site; and Academy Library Director Judy Dyki for helping at the last minute to shape the "Artists at Work" sections in the catalogue and serve as the final proofreader. Beyond the hot house, I thank Glenn Adamson at the Victoria & Albert Museum in London for his insightful view of fiber at Cranbrook from afar; catalogue designer Lucille Tenazas in New York —who also happens to be a 1981 graduate of the Design Department— for graciously accommodating our tight schedule and turning our images and words into a dazzling book; and our editor Dora Apel, an art historian at Wayne State University in Detroit, for once again helping the writers to focus and clarify their thoughts. Finally, we all thank Gerhardt Knodel and Jane Lackey for tending the hot house and nurturing the growth and development of their 275 students and, in the case of Knodel, for his vision as Academy of Art Director that has supported all of us in so many ways. At the bittersweet moment of the departure of both Knodel and Lackey, *Hot House* serves as a tribute to these two extraordinary artists and educators and displays the magnificent flowering that first began under their tutelage.

Gregory Wittkopp is the Director of Cranbrook Art Museum.

Gerhardt Knodel's Studio, 1978

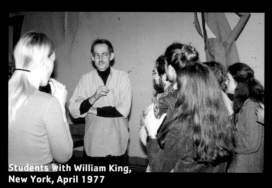

Students with William King,
New York, April 1977

The Dyer's Art Exhibition,
Cranbrook Art Museum, 1978

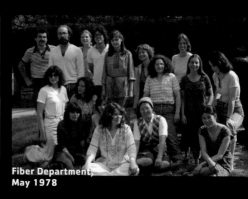

Fiber Department,
May 1978

A Pensive Moment, 1980

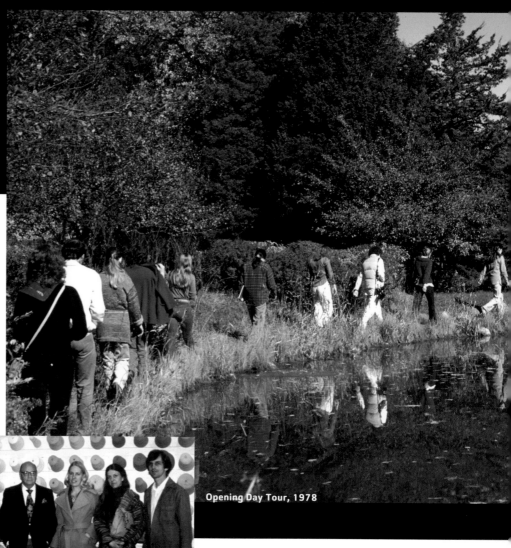

Opening Day Tour, 1978

Fiber Department at Boris Kroll's
Design Studio, New York

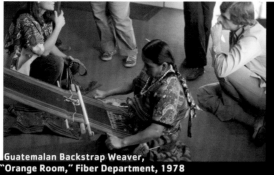
Guatemalan Backstrap Weaver,
"Orange Room," Fiber Department, 1978

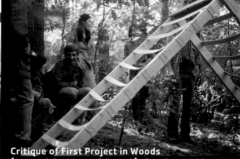
Critique of First Project in Woods
(Artwork by Howard Crouch), October 1978

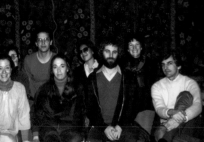
Fiber Department
Group Portrait,
February 1980

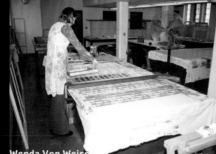
Wenda Von Weise
Working in Print Studio, 1978

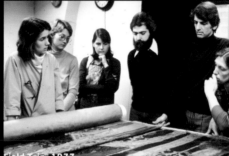
Field Trip, 1977

1976–1980

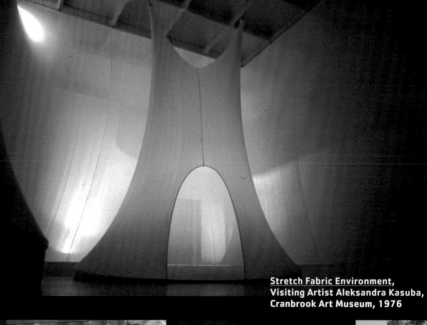
Stretch Fabric Environment,
Visiting Artist Aleksandra Kasuba,
Cranbrook Art Museum, 1976

Indian Textile Photo Session,
Gerhardt Knodel's Studio, 1979

Visiting Artist
Louise Nevelson, 1980

Cranbrook House North Lawn,
October 1978

HotHouse

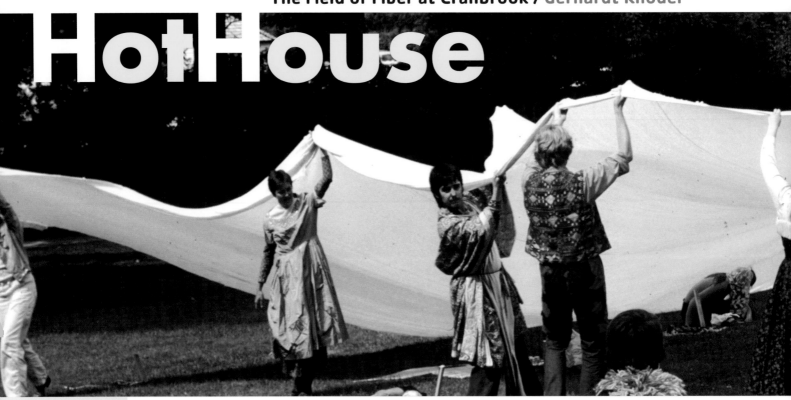

Years ago, in a discussion with several art historians in Europe, I learned that work in fiber, outside the respected tradition of tapestry weaving, had little potential to be considered art. Textiles were domestic. Art was of a higher calling. There was little chance for new work to break the barrier of strong associations with house and home. There was certainly little interest on the part of critics, curators or historians focused on the "fine arts" to actively consider expressive work in the fiber medium as being relevant to contemporary art.

Of course, that elitist attitude was precisely what fueled the passion of young artists bent on breaking stereotypes and accepted conventions, especially during the revolutionary counter-culture movement of the 1960s. In time, the gates of acceptance were pried open with Claes Oldenburg's soft sculpture, Christo's wrapped buildings, Robert Rauschenberg's quilt combines, Kiki Smith's embroidered nervous systems and Ernesto Neto's stretched tensile structures. With all of those accomplishments, in retrospect it is difficult to imagine what the problem was.

The textile field up to the 1960s was primarily oriented to the textile as utilitarian object (rugs, draperies, blankets, clothing). Even at Cranbrook Academy of Art, where the Fabric Design program was widely recognized as one of the country's best, students through the 1960s were encouraged to approach their work mainly through the lens of "design" as opposed to "fine art." Innovations resulted primarily through the incorporation of new materials, new structures and new patterns applied to well-established functional problems. The products of the department were intended to function mainly within the arena of architecture where they were appreciated for their decorative and functional qualities.

Among many students there was restlessness about breaking free of constraints and a desire to transcend the traditional sensibilities that attracted students to the field into unexplored territories, to discover something "new." The overthrow of conventions certainly had characterized the field of painting following the bold post-World War II era. The work of Abstract Expressionist radicals was paraded with pride around the world. The climate was ripe for new work in the fiber medium as well.

An analysis of accomplishments by students in the Fiber Department at Cranbrook Academy of Art must acknowledge the marginalization of the world of craft and design, to which the field of fiber was consigned, in relation to the world of art. As one reads the thesis statements by graduates from the 1970s through the 1990s, there is frequently an undercurrent of defensiveness or an aggressive

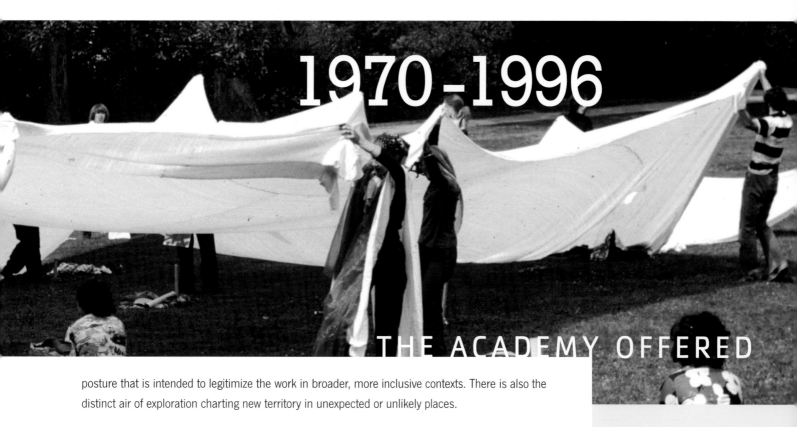

posture that is intended to legitimize the work in broader, more inclusive contexts. There is also the distinct air of exploration charting new territory in unexpected or unlikely places.

Who was listening to these young artists? What was required to bring these new approaches into a mainstream of interest, acceptability and respect?

Getting It Right With Oneself

Within months after my arrival at the Academy in 1970 it became clear that the greatest asset of the institution was its diverse student body comprised of ambitious individuals in pursuit of success. I immediately set to work reorganizing the space in our department from an open studio plan, characteristic of textile studios in most American institutions, to one in which all students had their own space, their own walls and a sense of privacy. If the business of the department was to become the development of individual talents, I was going to make accountability an individual matter. The challenge was in making the 24/7 social environment into a hothouse of individual productivity.

The studio in 1970 was occupied by a forest of twenty-two newly-purchased Cranbrook Looms (originally designed by Loja Saarinen). The implication was that everyone was expected to weave, or at least to coexist with the equipment. In 1971, with the closing of the Academy dining facilities and with a shortage of students interested in on-campus housing, our department was able to transform old dorm rooms into individual studios, and the old kitchen and dining facilities into shared facilities for dyeing and processing fabrics. At the same time we dismantled the forest, using looms only where necessary, and established a room devoted to discussions and critiques in what had been the dormitory lounge, known affectionately as the "Orange Room" because of the color of the burnt orange carpet seen in all the photographs of work taken in that room through the mid-1980s, and remaining as padding under the neutral gray carpet in place until the mid-1990s!

To my mind, the key to moving forward existed in the ability to articulate one's goals, understand those goals in a broader context and critically evaluate the work produced. Learning was to be an individual matter within a respectful environment of individuals existing in support of one another. I reasoned that all students should be able to accelerate their rate of growth, accomplishing in two years what might take them five or ten years to accomplish on their own. In the process, everyone in the studio functioned both as student and teacher.

Early on, I fell in love with the Cranbrook environment as an important resource, and early in the 1970s I annually initiated the academic year with an extensive tour intended to define the campus's nearly 320 acres as "home" for the students. We walked together through the woods to Cranbrook House where I invited Henry Booth, founder George Booth's son, to welcome everyone on behalf of his family's history; we walked the main aisle of Christ Church Cranbrook or through Brookside School to be reminded of the heritage of the Arts and Crafts Movement as motivator for development of the institution; we considered the extraordinary opportunity afforded Eliel Saarinen to build onto the founder's vision, speculating on what our own responses to that invitation might be; and we considered the potential and relevance of the artist/craftsman in our own moment relative to the tapestries, windows, furniture and architecture of Cranbrook and Kingswood Schools. We held a picnic at the Greek Theater or in the sunken garden close to Cranbrook House. And near the end of the first afternoon, I asked everyone to make their first artwork in a location of their choice somewhere on the grounds –to build something that would channel their creativity into the existing environment, a meaningful insertion, sensitive to the nature of the place, and leaving a trace of their attention. Three days later, those works became the first subject of our group discussions.

The following day, after all the students had introduced themselves with a slide presentation of their work, I began individual meetings to learn more about their scope of experience. For years I even conducted an inquiry into their level of knowledge of all of the basic technical and conceptual experiences that I regarded as fundamental to achieving mastery, or the designation of "Master" within the field. Next, we discussed the goals and plans for their course of graduate study, a subject that I often initiated in a letter that was sent mid-summer to begin the thought processes leading to action. Usually, I suggested that they simply "get to work" and anticipated having a body of work completed within a few weeks so that they could begin participating in the group critique process, and offered suggestions of reading material to assist in developing their study. This one-on-one relationship grew with experience. The Academy offered no guidelines, no process for approaching the education of students. In retrospect, the empty slate was a gracious and generous opportunity for discovery of new ways to communicate with students and assist in their growth as strong individuals.

The Tribe

By 1973 there were eighteen students in the department –the largest graduate program in the United States. The Vietnam disgrace had ended, Nixon was out, Academy graduate Jack Lenor Larsen was at the top of his form as America's number one fabric designer, macramé vests and tie-dyed skirts of Hippiedom were giving way to smarter ethnographic references in high fashion endorsed by Diana Vreeland, and a major European biennial, the *International Biennial of Tapestry* in Lausanne, Switzerland, was regularly presenting monumentally-scaled fiberworks that had evolved from the history of tapestry. These exhibitions sent waves of excitement through the textile studios in the United States as they validated what younger artists knew to be true –that their innovations deserved attention as art.

An echo of the Lausanne biennials called *Deliberate Entanglements*, presented at UCLA in the early 1970s, provided an opportunity to invite stars Magdalena Abakanowicz and Jagoda Buic to Cranbrook where their lectures were received with standing ovations. At last, the field had heroines and heroes to reference, just as painters and sculptors had their role models. The enthusiasm was so infectious that students initiated the idea of renaming the department from Fabric Design to the

more generic Fiber, a more inclusive designation. The department's identity and the strength of students' work were recognized in a 1974 exhibition titled *Fiberworks Now*, occupying the main galleries of Cranbrook Art Museum. The diverse works presented a true reflection of the newfound freedom that would characterize the field for years to come. Many of the works were intended to open new territory for considering the potential of fiber, experiments that became a fabulous resource even for artists outside the field.

I was delighted when the Lausanne Biennial accepted my own proposal in 1975 and again in 1977 and 1983. In each of those projects I solicited student assistance in building my large-scale works in order to share the excitement of the opportunity, the complexity of experiences involved, and to serve as inspiration for what they might also accomplish. I attended the openings in Switzerland, lectured there and elsewhere in Europe, visited the studios of many of the artists in the exhibition, and brought back to Cranbrook endless numbers of slides, reports and more visitors such as Sheila Hicks, Daniel Graffin, Josep Grau-Garriga, Lenore Tawney, Peter and Ritzi Jacobi, Claire Zeisler, Françoise Grossen and several of the directors of the Swiss exhibition. A number of Academy graduates who were increasingly influential in the evolving field also visited the department: Sherri Smith, Walter Nottingham, Jack Lenor Larsen and Ted Hallman. Olga de Amaral's work was frequently referenced in our discussions.

By the mid-1970s students were increasingly referring to the work of other artists in their field, and they became increasingly comfortable with references to artists and movements in the broader field of art as these artists aligned with their own work. But intellectual investigation depended almost entirely on writings about art in relation to histories of painting and sculpture. Especially frustrating to fiber students was the limited amount of good critical writing about new work in their medium and connected to the history of textiles. Well-known critics and historians of contemporary art were simply not comfortable writing about fiber works because they lacked expertise in the field. As a result, artists and students were compelled to pick up the pen and write for themselves, transcending the language of technical descriptions with subjective interpretations. Most notable was Magdalena Abakanowicz, whose elegant communications about metaphorical relationships between the body and the fiber medium became an important source of inspiration. At Cranbrook, students were encouraged to keep track of their own insights and intellectual discoveries in a written journal, just as they were expected to record the development of imagery by regular drawing in their sketchbooks.

A significant breakthrough occurred with the development of the Pattern and Decoration Movement in the late-1970s. A group of New York-based artists discovered a common interest in the history of patterned textiles as an expressive subject and rich resource for visual and intellectual inspiration. Everyone in the department who visited the 1979 Whitney Biennial with me was fascinated to see the extensive incorporation of fabric-based themes and their attendant cultural references in works by Robert Zakanich, Joyce Kozloff, Miriam Schapiro, Robert Kushner and Valerie Jaudon. These artists also offered alternative options for presentation of their work in the form of installations or even performances that spatially enhanced meaning and conflated traditions of theater, interior design, architecture and ritual with traditions of painting and sculpture.

My own interests in the history of textiles were given added impetus as I met a broader group of artists who shared my enthusiasm for examining the past as a means of opening new possibilities for the future. In Los Angeles I had studied the history of textiles with Stefania and Eugene Holt, curators of textiles

the tribe

at the Los Angeles County Museum of Art. Once in Michigan, I was delighted to be in the vicinity of the important textile collection at The Detroit Institute of Arts, the source of the textbook *Two Thousand Years of Textiles* written by curator Adèle Weibel. At Cranbrook, George Booth also had assembled a fine study collection of world textiles along with important tapestries housed in the Cranbrook Art Museum. My personal interests and research, focused on architectural textiles and their influence on human habitation, led me to some far corners of the world. By the late-1970s I had traveled in Europe, Turkey and other Near Eastern countries, Iran and Afghanistan, and India.

In 1976, with an individual artist grant from the National Endowment for the Arts, I was able to take my first round-the-world trip in search of architectural textiles (tents, canopies and other portable enclosures) for inclusion in a proposed exhibition, the first ever on this subject. In my four-month absence from Cranbrook, I invited Phillip Warner, an inspired young artist and textile designer working with Jack Lenor Larsen in New York, and a 1973 graduate of the department, to lead the program. He was joined by Aleksandra Kasuba, an architect who had recently transformed the interior of her New York City brownstone with an organic configuration of stretch fabric walls. Both arrived with a passionate perspective and an ambitious agenda for the students. My exhibition plans were thwarted by a number of unexpected events, including important opportunities for architectural commissions such as a huge installation for the new Renaissance Center in Detroit completed in 1977, and a major project for Xerox Corporation the following year. I was able to use my travel contacts to good advantage, however, especially for developing a course in the history of fabrics.

World Travel with Consequence

I regularly returned from annual travels with suitcases full of old textiles that I was anxious to share with the students as a primary source of inspiration, showing them what was possible and conveying something about the exotic environments and circumstances that produced such extraordinary products. I was quite confident that most of the objects I shared with the students provided new experiences for them. After all, since we were mining contemporary living experiences for firm foundations on which to create new works for our own time, why couldn't splendid examples from the past, rich with narrative or traditions of use, inspire our own search for fresh perspectives? One had only to approach the past with an open mind and an eye for discovery. Additional incentive was provided by the fact that my beginning-of-the-year surveys revealed that although the majority of the students had studied art history, fabrics were not included. I was determined to bring this dimension of education to the students as a way to contribute to their qualifications and mastery in the field.

A Fabric History course began to take shape in the mid-1970s with occasional lectures that took place in the Art Museum where I could use examples from the museum's study collection in relation to my own. By 1980, the course was formalized into a series of twenty-two twice-weekly lectures over the course of one semester, offered once every other year. The course content began in prehistory, and moved from East to West over more than 2000 years: from Ancient China, the classical world of antiquity, silk-road cultural migrations, Egyptian and Near Eastern developments, and Islamic textiles, to the evolutions of European textiles, including influences from India and America, the Industrial Revolution and the Arts and Crafts Movement of the early twentieth century. The course became the only Academy program where students were required to take a mid-term and final exam, and write a research paper as well! I reasoned with the students that if I was going to invest the time to prepare for twenty-two two-hour lectures, I deserved their active participation as a reward. On alternate years, I offered more sessions to stimulate

interest in the products of cultures outside the range of the Fabric History course: Japan, Indonesia, South America and Africa.

At various times during the course, I invited to Cranbrook a traditional Mayan backstrap-loom weaver from Guatemala; a batik artist from Java; a bobbin-lace maker; and numerous museum curators or dealers in old textiles. The course provided good reason to regularly visit museum collections in New York, Cleveland, Chicago and Toronto, and coalesced interest for departmental travel to Mexico City, Oaxaca, England and Scotland. The department also produced several Art Museum exhibitions wherein contemporary work was juxtaposed with ethnic or historic counterparts. But most important was the influence of this study on the work of a number of students.

For students interested in weaving, one of the greatest challenges was to unite technique with image and content in new ways. One subject that triggered an impressive response was a group of Indonesian textiles that I brought back from Sumatra. These weft-brocaded ceremonial cloths, called *palepai*, presented the weaver's extraordinary ability to draw figurative images in the construction of the textile. The textiles showed expressive narratives with fantastic human and animal figures combined with images referencing the ceremonial context in which the textiles were actually used. *Palepai* also presented compositional harmony between the weaving process and the resulting images, and complex patterning that energized the subject and the textile as object. These textiles unlocked many creative responses and produced a large body of influential work by many outstanding weaving students in the 1980s.

The 1980s

Between September 1980 and May 1982, I took advantage of the first sabbatical leave awarded at the Academy. Not satisfied with a one-semester period of work, I requested a leave of absence to extend a four-month sabbatical to two years! I needed enough time to truly experience being an artist on a full-time basis, including an opportunity to test my ability to financially sustain my professional practice. Up to that moment, my studio work had been supported by teaching. It was high time to test myself as an artist outside the academic environment. Academy of Art President Roy Slade agreed to the arrangement, provided I agreed to return! I purchased and renovated an old cigar factory north of Cranbrook in downtown Pontiac, and set to work as one of the first artists to establish a studio in that city.

Joan Livingstone agreed to lead the program for that two-year period, and did so creatively, with dedication, and with an impressive intensity of production that affected both her students and her colleagues. Many people in the community still recall some of the highlights of her work, including the brilliant fashion show/performance/happening presented in the Art Museum in the spring of 1982, a vast edgy collaborative effort involving students throughout the Academy.

The results of my two-year leave were presented in a large exhibition at Cranbrook Art Museum in the fall of 1982 titled *Gerhardt Knodel Makes Places to Be*. Included were projects such as *The Pontiac Curtain*, a fourteen-by-thirty-six-foot woven "tapestry" engaging life-size photographic images of occupants of main street buildings in the derelict downtown; fourteen wall-related weavings; models and drawings of architectural projects in process in several United States cities; and a theatrical installation intended as an environment to stimulate response from dancers, musicians

and other creative artists invited to perform during the course of the exhibition (this installation was reinstalled at the 1983 Lausanne Biennial). The Cranbrook exhibition and catalogue opened many doors of additional opportunity in subsequent years.

A second opportunity presented itself when I received the United States Japan Friendship Fellowship for seven months of study and travel in Japan in 1985. The experiences provided extensive and unlimited access to, and established an important foundation for my fuller appreciation of, the depth and dimension of Japanese culture. My study focused on the use of space in Japanese theater and on Japanese festivals that were traditionally rich with historic objects and rituals. The experiences also affected my sense of "craft," especially the element of time, and the appreciation for refinement and patience in the process of "getting it right," qualities which had a great affect on my work with students at the Academy.

Throughout the 1980s I frequently looked to architecture for inspiration and insight. An important issue had to do with locating one's work with a sense of belonging. The world was full of orphaned artworks. What about textiles that last because they are needed, because they fit by intention of their maker, and because the audience understands its relationship to the textile? Beginning in the mid-1970s we looked at Bernard Rudofsky's text *Architecture Without Architects*, a fabulous representation of the human biological imperative to build harmoniously, in relationships, and to build with authority at a size larger than the human being. Also important to us was the fact that the majority of materials used in the photographic examples were from fiber.

Our seminar discussions of *Psychology of the House* by Oliver Marc explored collective consciousness regarding the use of architectural space investigating relationships between the expressiveness of inner and outer space relative to the human body, through which we may come to terms with resources that are overlooked in contemporary architectural practice. Marc's analysis drew on references from many cultures of the world, finding commonalities that provided a new basis for response.

A third resource used for a series of seminars in the Fiber Department was *Genius Loci: Towards A Phenomenology of Architecture* by Christian Norberg-Schultz. The book presented an enlightening analysis of three man-made locations offering unusual experiences with architectural interrelationships: Prague, Khartoum and Rome. The author's analysis of the phenomenology of place as the starting point for meaningful intervention of new architecture provided an alternative means for considering the point of departure for our creative work. The analysis was especially useful in stimulating provocative thoughts about connections between conditions that brought forth great architectural environments and conditions which produced great textiles in the past.

The theme of locating one's work within meaningful context inspired and defined by living experiences was given further impetus by the arrival of Joseph Campbell's *Power of Myth*, a video-taped series of interviews that was presented at the Academy in 1988. Campbell's brilliant commentary on the importance of "expanding the place of mystery" in our lives, and his depiction of the ways people of the past evoked their higher nature with rich mythology, inspired students who were searching for meaningful content as a starting place for their work. Experiences with Campbell's ideas were further developed by departmental travels to Mexico and the subsequent production of a body of work presented in an exhibition at the Art Museum in response to themes inspired by Mexican culture.

The Feminist Movement and the Fiber Department

Throughout all the years represented in this survey, the Fiber Department was mostly populated with women since most undergraduate textile programs (the source of many of our graduate students) primarily attracted female students. Many of those programs typically characterized the field of fiber as being associated with "feminine" values that perpetuated a love of making within conventional definitions generated as far back as the period of the Arts and Crafts Movement. Few people outside the discipline were aware that the field was offering an alternative and distinctive approach to art.

The greatest influence of feminism within the field of fiber was the insistence by many successful feminist artists on a more expansive approach to art, and a language to critically support the work and give it "legs" within the broader field of discourse on art and culture. It was also significant that the materials and subjects used by early successful feminist artists brought a new legitimacy to work explored in the fiber medium, and heightened awareness of the expressive associations generated by fiber work, especially in relation to the "domestic." Despite the obviously strong associations, there were few early feminist artists that developed their own voices within the context of the fiber field. Instead, they functioned within the establishment of painting and sculpture where they stood in greater tension with male-dominated art, and where there existed an establishment of critics prepared to publicly take on the challenges. Still, the dialogue generated by feminist artists did find its way into critical discussions within the Fiber Department at Cranbrook and initiated the gradual and progressive migration of issues and ideas from the Fiber Department into other fields of study.

By the 1980s, the most influential effects of the movement resulted from revisionist thinking that validated intellectual deconstruction of fact as an important dimension of the artwork. Among many useful texts that inspired departmental discussion was *The Subversive Stitch* by Rozsika Parker, which offered an expanded way of considering the history, practice and cultural implications of embroidery that opened paths to new work. A number of influential visiting artists contributed to the dialogue generated by the feminists, including Miriam Schapiro, Janis Jeffries, Ann Hamilton, Richard Martin and Joan Livingstone.

1970-1996

The Early 1990s

In 1991 Suzi Gablik published *The Reenchantment of Art*, a book that united the conceptual position of students in the Fiber Department with broader issues of survival. Students at the time appreciated the vital role played by the fabric products of past cultures, but they questioned the relationship between contemporary artistic practice and the increasingly complex field of conditions challenging human survival. They reasoned that art had to move from preoccupation with content or style to issues of environmental and social responsibility. Gablik encouraged a reshaping of the paradigm for living to one that is more socially interactive, one that shifts emphasis from objects to relationships, one that "allows for a return of soul."

Interestingly, the majority of students with whom I have worked tend to be fundamentally optimistic. They are builders and creators. In contrast to many of the dominant voices in the critical community of the time who were dedicated to deconstructing meaning thereby often sapping power and generating cynicism, Gablik's message was appealing: "What makes things happen is believing that they can happen. The primary catalyst is saving the earth. Nothing else matters. Restoring awareness of our symbiotic relationship with nature becomes the most pressing spiritual and political need of our time."

Also inspiring careful reflection on the human condition was Diane Ackerman's *A Natural History of the Senses* published in 1990, a widely-read book that expanded understanding of one's physical being and the power of communication via the mechanisms shared among all people.

Our departmental discussions based on Gablik and Ackerman were complemented by an extraordinary traveling exhibition organized by the Los Angeles County Museum of Art, *A Primal Spirit: Ten Contemporary Japanese Sculptors*. Several of the students in the department in 1990-1991 saw the exhibition, and everyone had access to catalogue photographs that presented monumental installations focused on the expressive power of natural materials, advocating through their powerful presence an acknowledgment of something fundamental, essential and sensual.

In a 1991 catalogue documenting a group exhibition of the Fiber Department, *Eighteen Times One*, at the Michigan Design Center, I acknowledged some of these influences on the students' work:

The struggle for human survival is projected into our lives on a daily basis. Perhaps through desperation we look to other forms of life –the earth, the sky and sea– for reassurance about the very act of living. Many of our institutions may be in shambles, but the sunset survives and its unending performance is forever dignified.

The field of fabrics has always had to contend with the physical vulnerability and impermanence of cloth, conditions that are now explored by many artists interested in representing the human body. These new forms, often sculptural in nature, aspire toward becoming surrogates of the human being, or surrogates of the human psyche, dynamically capturing space in time for acting out their persona, like watching one's own shadow leave the body to pursue an independent activity (life) while still tethered to it.

Many of the works in this exhibition exist as projections of the self in search of meaning. They show, in a disjointed way, the imperfections of life, the awkwardness of people honestly in search of their own identity.

Today, the lifestyles and commitment sustained by many of the students who came through the program in the 1990s substantiate the transformative influence of that time of awakening.

In January 1995, as a result of unexpected circumstances, I was asked by Dr. Lillian Bauder, then President of the Cranbrook Educational Community, to become Acting Director of the Academy. I agreed to take on the responsibility for four months while continuing to lead the Fiber Department. Later that year I was appointed Director by the Academy's Board of Governors. I continued to work with students in the department until 1996 when it became clear that a transition of leadership was necessary. Fortunately, Margo Mensing was able to lead the program from September 1996 to May 1997 as Acting Head of the department. Margo brought to the Academy her special interests in installation work and astute critical skills, which greatly contributed to the experiences of students throughout the Academy.

In the spring of 1997, it was my great pleasure to appoint Jane Lackey as the next Artist-in-Residence and Head of the Fiber Department, a new leader in the hothouse.

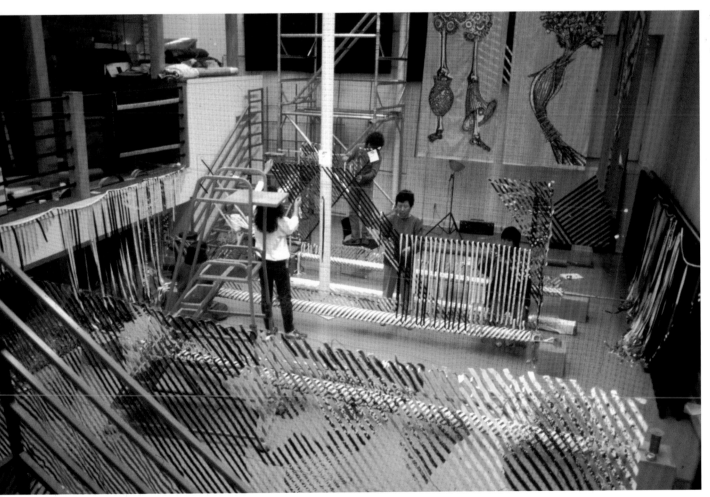

Gerhardt Knodel Recruits Students to Work in his Pontiac Studio

Going Away Party Before
Gerhardt Knodel's Trip to Japan,
December 1984

Fiber Department Graduates,
May 1985

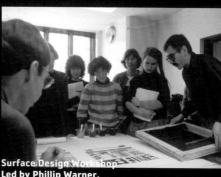
Surface Design Workshop
Led by Phillip Warner,
February 1985

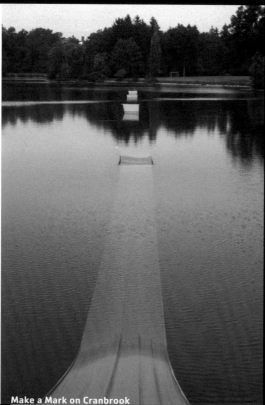
Make a Mark on Cranbrook
First Week Project, 1985

In Situ, Morgan Clifford,
Spring 1985

Critique in Greek Theatre,
Cranbrook Campus, 1982

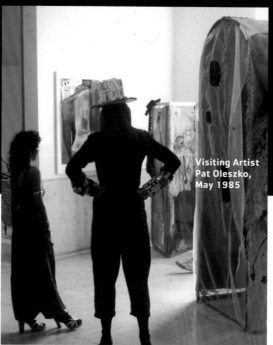
Visiting Artist
Pat Oleszko,
May 1985

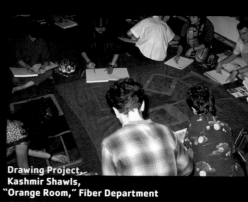
Drawing Project,
Kashmir Shawls,
"Orange Room," Fiber Department

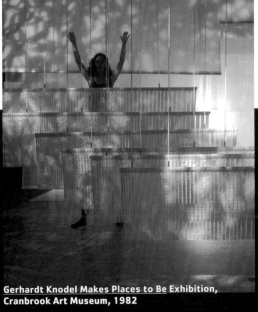

Tour of Detroit in
Rented Van, 1984

Gerhardt Knodel Makes Places to Be Exhibition,
Cranbrook Art Museum, 1982

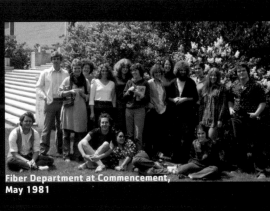

Fiber Department at Commencement,
May 1981

1981-1985

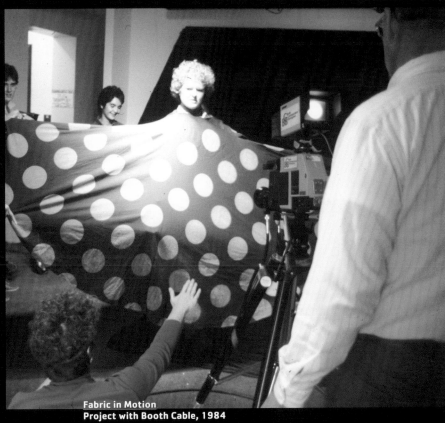

Fabric in Motion
Project with Booth Cable, 1984

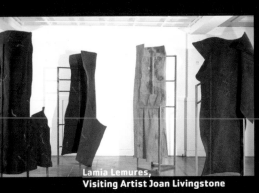

Lamia Lemures,
Visiting Artist Joan Livingstone

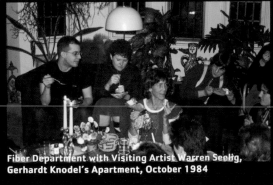

Fiber Department with Visiting Artist Warren Seelig,
Gerhardt Knodel's Apartment, October 1984

Academy Fashion Show,
Cranbrook Art Museum,
1982

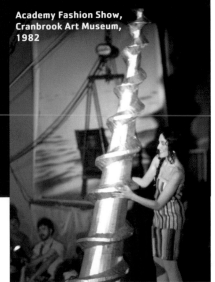

One spring day in 2007 as I walk up the stairs

of the Rafael Moneo-designed New Studios Building to the top floor and head towards my studio in the Fiber Department, my attention is drawn to an object with an odd look made by two students and left in the hallway. Glancing at its physical make-up, I see a squarish, completely soft chair supported by internal stuffing and sewn geometric fabric construction. It looks like something that could be purchased at IKEA, a blend of modernist form and dorm room comfort. Where a body would touch the seat, back and arms, the chair is covered with sturdy well-stitched black/gray industrial-grade upholstery material. Most likely it is fabric used in the car industry. One of the students was trained in car upholstery techniques and came here with surplus supplies. This material is joined with clear plastic panels that make up the sides, bottom and back. The slightly abject comical part is that at the end of each armrest and at each top corner on the seat back are sewn,

reinforced holes where one can stuff the refuse of packaged food or other detritus —pop cans and wrappers peek out of the portals —so it's a self-stuffing chair —the more stuffing the more support. Is this leisure propping up leisure? Colorful logos can be seen through the plastic. Eating, relaxing and disposing of the trash are all wrapped up in one object. This was made as a collaborative effort between the upholsterer and his fellow student, who gathers materials dropped off at her studio entrance and gestures towards a sustainable studio practice. Not-pillow, not-chair, not-recycling bin, not-design, not-art, not-craft and yet all of these things —interesting, how did we get to this expanded hybrid practice and where are we?

In 1979 Rosalind Krauss published a breakthrough essay in *October*, "Sculpture in the Expanded Field," in which she speaks of an expanded field "generated by problematizing the set of oppositions between which the modernist category *sculpture* is suspended." Arguing that sculpture is no longer dependent on a particular medium, Krauss suggests, "the logic of the space of postmodernist practice is no longer organized around the definition of a given medium on the grounds of material, or, for that matter, the perception of material. It is organized instead through the universe of terms that are felt to be in opposition within a cultural situation."

One of the most compelling aspects of fiber and the newly defined material study is that it asks us to perceive with all of our senses, traversing and mediating high art/low art and mind/body divisions. The development of relationships that bridge these poles have motivated works in numerous formats during the past ten years in the Fiber Department. One of the most effective methodologies for such work is interactivity. The audience, artist or select communities interact with and sometimes produce the work collaboratively as a means of experiencing it more fully and through multiple modes of reception and participation. Collaborative production in which a community pitches in and makes something together is long established in craft traditions and offers a model for social interface, inviting the audience to be participants. Installation, performance, photo and video documentation, social involvement, websites, collections and archives are only a few of the modalities used.

Parallel to the interest in interactivity has been the agency gained from taking things apart both conceptually and physically. Someone studying fiber and materials in the early formation of the field might have learned complex processes involving relationships of content and form that are locked together within a structural network. A textile by its very nature is a finely

Taking Things Apart

The Field of Fiber at Cranbrook / Jane Lackey

1997-2007

interlocked mesh —idea and image meet in a matrix of surface structure that to be fully understood must be spread open, reversed or magnified. Through locking and unlocking structural relationships, these intricacies may be broadly recast into different positions and materials, physically and conceptually challenging notions of textiles.

What has been interesting to me over the course of my own studio practice and that of students and colleagues is how this notion of teasing information out of a web has grown through its relationship to digital technologies, animating analogies of form and materials as they link to webs of information and language. Like scientists, we look at the smallest particles of matter and discover structure in formation. Here and especially within the magnetic spaces between are ephemeral moments of connection and reminders of textile interlacement. This elusive network surrounds us like a skin and tells our story.

Fiber inherently is an art medium where materials and process meet and cross to form something not entirely new but not quite familiar either. These intersections have always occurred quite naturally within the production of textiles. A silk-screener is most likely steeped in

photographic images and pattern design. Weaving requires knowledge of structure, mathematics, material properties, software or digital interface. Dyeing and surface intersect with issues in painting, drawing, even organic chemistry. Clothing overlaps with performance and fashion. Sculpture moves towards installation and architectural skin/bone relationships. Designers merge boundaries of psychology, design, art and decoration as they address use and function.

Fiber, the material, is an ever-expanding glossary. Its history can be traced through at least three overlapping strands that are often blended and used as frameworks to develop new modes of working. In the first strand, the narrative of cultural and domestic textiles from around the world is located in human social exchange, ritual, celebration, identity, status, gender and labor. Discovering traces of human history in cloth became an important aspect of academic study in fine art fiber programs and contemporary practice beginning in the 1970s.

A parallel survey of the history of fine art reveals that cloth has long been a subject for painting and sculpture and eventually appeared as a real material within movements such as Surrealism, Arte Povera,

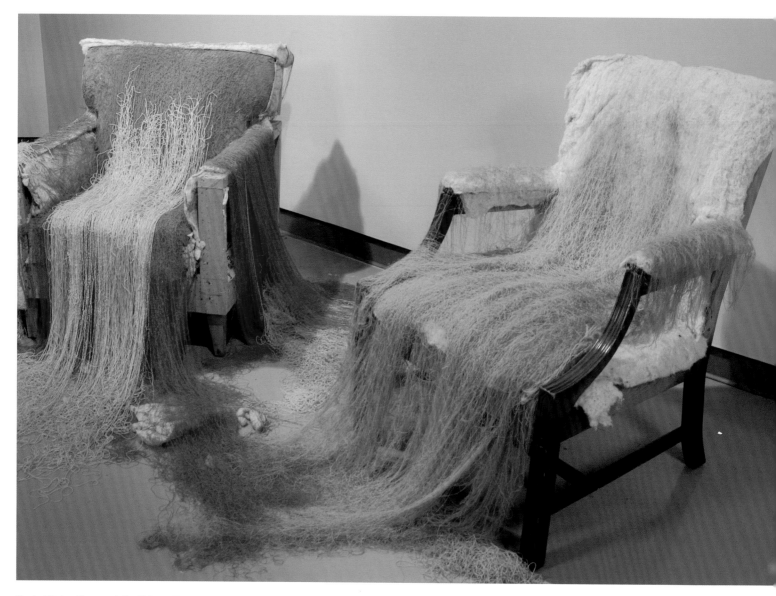

Post–Minimalism and Art Fabric. The intense force of the 1970s Feminist movement interrupted art practice as we knew it and proposed a fresh set of considerations about how art is materialized, made and received.

World culture and fine art histories join with the momentum of modern and contemporary textile and fashion design comprising a third strand of influence. Here there have been groundbreaking technical innovations within production and new reasons for developing "extreme textiles." New technologies, materials and methods of fabrication have changed both design practice and practitioner. For studio artists and entrepreneurial designers, a rich territory of exploration or stance of opposition is cultivated around technologies that challenge and delineate notions of handcrafting, function, labor, machine control, materiality and immateriality. Removing the hand from production often fuels haptic assertion and insistence on it. Technology combined with handcraft yields hybrid discovery, while outsourcing, a viable production option, demands collaboration and a different set of skills.

By the late 1990s when I came to Cranbrook, fiber was moving away from the margins and into the mainstream. Artists were more aggressive with their selection of everyday and ephemeral materials. Art in the 1990s experienced a return to the use of pedestrian "stuff" as a way of conveying meaning. Domestic, industrial and organic substances with their connection to everyday reality —intimacy, the sensory, the political, the personal, the cultural, the portable— suited Postmodern discussions of identity, gender, globalism, AIDS, marginalization and the body. Within academic programs, the emphasis on the meaning of material exploded and shifted the force of transposing tactile/textile sensibilities to a wide range of experimental, pliable ideas, materials, actions and responses.

Several key writers emerged within the field of fiber and began to articulate and map out positions of production and reception, aligning theory with form, process and content. Noteworthy among these influences was Margo Mensing whose many articles and essays clearly analyzed distinct conceptual strategies emerging within the field. Prior to my arrival in 1997, her thinking and her work specifically influenced students at Cranbrook where she was Artist-in-Residence during the 1996-1997 academic year. In 1998, Ingrid Bachmann and Ruth Scheuing edited the important book of essays, *Material Matters:*

"...students come to Cranbrook to experience the freedom and intensity of the think tank environment that it is."

1997–

The Art and Culture of Contemporary Textiles. Gerry Craig's insightful artist profiles and reviews appeared in broad-based art publications. Large-scale projects developed at The Fabric Workshop in Philadelphia by well-known artists newly introduced to fiber gained visibility through publications and museum exhibitions seen at The Detroit Institute of the Arts and around the country. Many of these large-scale installations produced collaboratively between artists and workshop technicians ignited an interest in fiber's relevance and breadth. The John Michael Kohler Arts Center in Wisconsin hosted exhibitions curated by Alison Ferris such as *Discursive Dress* (1993) and *Conceptual Textiles: Material Meanings* (1995). Joan Livingstone and Anne Wilson curated *The Presence of Touch* (1996) contrasting and connecting haptic and sensory production values with that of virtual experience. In 1999, Irene Hofmann, then Curator of Exhibitions at Cranbrook Art Museum, and I curated the international exhibition *Skin*, which explored how the materials and artistic sensibilities central to the field of fiber had become common currency in the broader field of contemporary art. The exhibition and symposium explored shared interests in the sensual, tactile and symbolic qualities of surface or "skin" in the works of Dorothy Cross, Yael Davids, Anne Hamilton and Ernesto Neto, who used performance, photography, video and sculpture. The works involved highly sensuous materials, actions and social interface.

The folds and seams of these conditions and histories contain areas of exploration that many artists continue to pursue and articulate. The contemporary practitioner might be seen in any number of exhibitions and publications, though to be tagged as a "fiber" artist these days is often seen as limiting rather than useful. By assuming overlapping influences, fiber emerges as a compelling, complex and often misunderstood field of study. Both a material and conceptual field, it is suspended between these varied sets of oppositions whose porous boundaries are stretched.

My students come to Cranbrook to experience the freedom and intensity of the think tank environment that it is. They want to explore shifting definitions within their own work that connect with the multi-faceted context of fiber and to join with other disciplines in pursuit of relevant and timely art practice. Fine art versus craft dichotomies or hierarchies of disciplines are outdated. More relevant is what makes fiber distinct and how these qualities can be savored and enlivened in times when categories are so easily collapsed. Many students have been trained with backgrounds in fiber. Many others are self-taught or find their way by

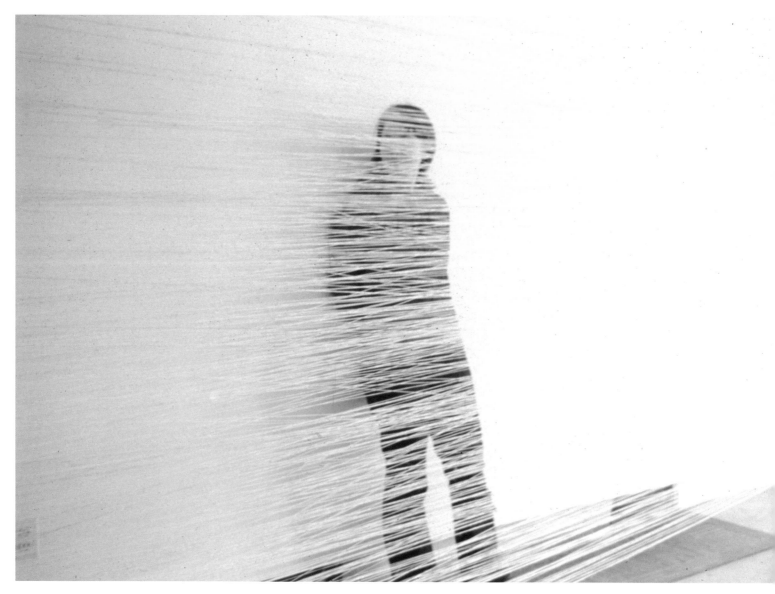

grafting fine art and design disciplines onto other disciplines such as creative writing. Ultimately, they locate and understand their work's concentration as it is revealed and delivered through the study of physical materials and subject matter.

The two years of graduate study is taken on both individually and within the atmosphere of exchange, dialogue and critique. Each participant offers vital ingredients of his or her distinct training and experience shaping a department that fluctuates yearly with new influences, motivations and dispersals of skill or expertise. My role has been to question and provoke and to ask for full and unrelenting participation. In a relatively small community of fifteen to seventeen people, each inquiry and process of development is visible to the group and forms the basis of readings, discussions, critiques and seminars. This substrate of overlapping concerns is fed through a sequence of post-studio presentations, writings, research and collaborative undertakings that exist alongside individual studio practice. Throughout the year attention oscillates between community and individual, never getting comfortable in either position. When the department moved to the top floor of the New Studios Building in 2002, the equality, proximity, transparency and openness of the studios cast a fresh and revealing light on the department, bringing students into tighter alignment and making them more visible to each other. In planning the layout and use of space in the studio, my goal was flexibility within structure. Traditional equipment and processes are available yet made moveable and fluid within the space to accommodate the hybrid practices that develop and mutate over the course of the year. The entire space, including my studio, is connected by a long axis where much takes place in passing and intuitive exchange. Daily studio practice is not that separate from patterns of living.

How is it possible to move beyond this fitting network of conditions at Cranbrook to have a voice within a broader community? A small but consistent stream of individuals has looked to Detroit and its neighborhoods as a place of study and site for their work. Yearly, we are influenced and challenged by a distinguished group of visiting artists, curators, writers and critics who visit Cranbrook. Anne Lindberg made a lasting impression on the department through her mentorship during the spring of 2005 while I took a sabbatical that coincided with my Fellowship at the Camargo Foundation in France.

"Fiber inherently is an art medium where materials and process meet and cross to form something not entirely new but not quite familiar either."

2007

During my ten years at Cranbrook, the department has taken cues from the nomadic medium of fiber by going in search of other communities: travel to visit artists' studios, museums, curators and sources of inspiration all over the world. With assistance from the Venture Fund started by Academy of Art Director Gerhardt Knodel and support from the owners of Hi-Tex, Inc. in exchange for textile designs, we have traveled to Spain, Turkey, Chicago, Mexico, New York, Montréal, Toronto and South Korea. Some of our most meaningful seminar discussions happened on a train somewhere between upstate New York and Montréal regarding the significance of specific "places" in today's global art scene.

As the smell of cooking from the studio kitchen lingers in the hallway, I think about the overlapping concerns of sustainability, use, permanence, wonder and imagination and return to the question I started with: Where are we? My students' words help provide a bridge. In the fall of 2006 in Toronto, a department exhibition of portable works carried to a gallery on our laps by subway was a key event. From their statement about this exhibition at the Annex Art Centre, they pinpoint their concern:

With What We Can Carry is the resolve of a group of fiber artists directly addressing the topics of mobility and adaptability. There is portability in the quality of our materials, the tension within the discipline, the themes in our individual work and transient lives. Built as adaptable beings, adjustment is the basic tool for our bodies and minds to survive. Today, the need to adapt to a world that is in flux, expanding further into our physical and virtual landscapes, has been heightened.

Contemporary life is full of tipping points, contradictions and moments of beauty and tragedy. The strange chair I reflected on as I entered the studio iterates some of the poignant combinations needed to address such complexities. Beyond a creative, resourceful use of material and form, I am comforted by the fiber medium's flexible and adaptive capacity for relevance. Fiber is a living medium, always asking questions, meeting oppositions and offering resistances, while opening an ever-expanding field of possibilities.

Deborah First at Loom, 1986

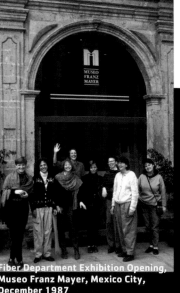
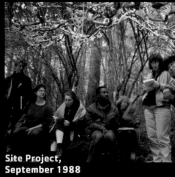
Fiber Department Exhibition Opening,
Museo Franz Mayer, Mexico City,
December 1987

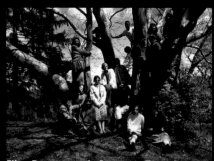
Fiber Department in Sycamore Tree,
Cranbrook Campus, 1988

Site Project,
September 1988

1986–1990

Monte Albán, Mexico, 1990

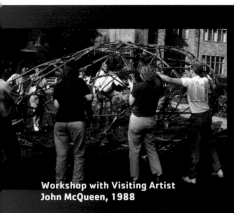
Workshop with Visiting Artist
John McQueen, 1988

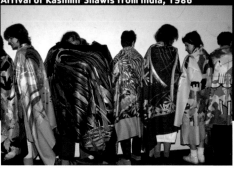
Arrival of Kashmir Shawls from India, 1986

Gerhardt Knodel's 50th Birthday Party,
Artpack Services Inc., Farmington Hills,
Michigan, 1990

Visit with Collector
Lydia Winston Malbin, New York, March 1989

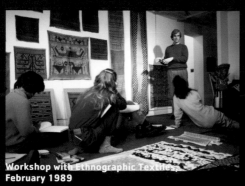

Workshop with Ethnographic Textiles,
February 1989

Drawing Workshop with
Visiting Artist Harry Boom,
March 1987

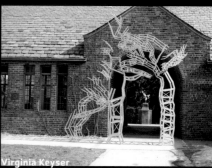

Workshop with Visiting Artist
Sheri Simons, 1990

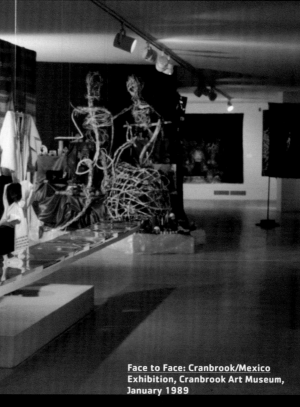

Face to Face: Cranbrook/Mexico
Exhibition, Cranbrook Art Museum,
January 1989

Virginia Keyser
Responds to Eliel Saarinen's Arch, 1987

End of Reviews Party, 1986

Lenore Tawney and Fiber
Department Students in
New York Studio, 1989

Visiting Designer
Jack Lenor Larsen, April 1986

Cranbrook Regatta,
Kingswood Lake, 1990

Visiting Artist Harry Boom with Fiber
Department Students, 1990

1970-2007

HotHouse

Expanding
the
Field
of
Fiber
at
Cranbrook

Artists in the Exhibition

1	Susan Aaron-Taylor	1973
2	Jennifer Adams	2001
3	Chris Allen-Wickler	1991
4	Paula Stebbins Becker	1993
5	Claire Begheyn	1979
6	Elizabeth Billings	1989
7	Beth Blahut	1995
8	Sandra Brownlee	1981
9	Mira Burack	2005
10	Carol Burns	1985
11	Nick Cave	1989
12	Kyoung Ae Cho	1991
13	Sonya Clark	1995
14	Barbara Cooper	1977
15	Annet Couwenberg	1986
16	Julie Custer	2003
17	Christina P. Day	2006
18	Kristen Dettoni	1993
19	Robyn Dunbar	2000
20	Layne Goldsmith	1979
21	Rita Grendze	1994
22	Marcie Miller Gross	1990
23	Wen-Ying Huang	1993
24	Hiroshi Jashiki	1983
25	Geary Jones	1981
	and David Johnson	1981
26	Mary Anne Jordan	1985
27	Sarah Kabot	2002
28	Emily Keown	2005
29	Wook Kim	2002
30	Jessica Kincaid	1999
31	Libby Kowalski	1981
32	Andrea Gaydos Landau	2005
33	Mi-Kyoung Lee	1998
34	Anne Lindberg	1988
35	Joan Livingstone	1974
36	Lisa Lockhart	1983

37	Wesley Mancini	1977
38	Fuyuko Matsubara	1984
39	Abbie Miller	2007
40	Kristen Miller	1993
41	Emiko Nakano	1987
42	Abigail Anne Newbold	2005
43	Laura Foster Nicholson	1982
44	Ólöf Nordal	1991
45	Michael Olszewski	1977
46	Erin Shie Palmer	1993
47	Kinnari Panikar	1985
48	Sina Pearson	1972
49	Helen Quinn	2000
50	Rowland Ricketts, III	2005
51	Jann Rosen-Queralt	1976
52	Judi Ross	1995
53	Lauren Rossi	2006
54	Arturo Alonzo Sandoval	1971
55	Laura Sansone	1994
56	Liz Sargent	2002
57	Warren Seelig	1974
58	Anne Selden	2005
59	Piper Shepard	1988
60	Sheri Simons	1985
61	Lucy Slivinski	1984
62	Koo Kyung Sook	1987
63	Kaori Takami	1998
64	Katarina Weslien	1980
65	Anne Wilson (BFA)	1972
66	Seth Winner	1997
67	Bhakti Ziek	1989
68	Gerhardt Knodel	
	Artist-in-Residence	1970–1996
	Academy of Art Director	1995–2007
69	Jane Lackey	1979
	Artist-in-Residence	1997–2007

This list includes the names of all of the artists with work in the exhibition who graduated from the Fiber Department at Cranbrook Academy of Art. Unless noted otherwise, all of these artists received an MFA in Fiber and their year of graduation is noted. If the work in the exhibition is the result of a collaboration, the additional artists are noted in the Exhibition Checklist.

The Curatorial Statements in the Exhibition Portfolio on the following pages were written by Cranbrook Art Museum Curator Brian Young in consultation with *Hot House* Editor Dora Apel, Gerhardt Knodel and Jane Lackey.

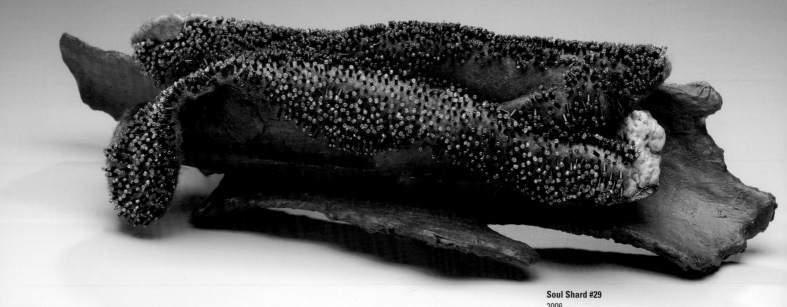

Soul Shard #29
2006
Bark, felt, beads,
coral, raw flax, kozo

1

Susan Aaron-Taylor Cranbrook Academy of Art, MFA, 1973

Susan Aaron-Taylor believes that over time the connection between one's soul and body weakens.
Through her *Soul Shards*, the artist has reordered organic and manmade materials that she feels can
counter that destructive process. Her *Soul Shards* are a synthesis of the materials found in nature
and a personal intervention to harness its intangible powers.

Born 1947, Brooklyn, New York
Wayne State University,
Detroit, Michigan, BS, 1969

Aaron-Taylor lives in Pleasant Ridge,
Michigan, and is a Professor and Section
Chairperson in the Crafts Department at
the College for Creative Studies in Detroit,
Michigan.

2

Jennifer Adams Cranbrook Academy of Art, MFA, 2001

With the primary commercial application of *Infusion* that of domestic comfort and hospitality, Jennifer Adams
finds nostalgic inspiration in a variety of sources. Adams crosses over boundaries and draws from memories
of home as well as experiences in which she found beauty or comfort, including a bouquet of flowers,
New York City water towers, and her father's drafting table. The resulting pattern invokes those elements
infused with a controlled energy.

Born 1970, Scranton, Pennsylvania
Philadelphia College of Textiles & Science,
Pennsylvania, BS, 1994

Adams lives in Rutherford, New Jersey, and is
a freelance jacquard designer for Wearbest
Sil-Tex Mills in Garfield, New Jersey.

Infusion (Anise)
Designed 1999; released 2001
Rayon, polyester,
Woven Crypton® finish

Momentum Textiles,
Irvine, California (Distributor)

Visible Soul, Red
1995
Beads, thread, river rock

Visible Soul, Yellow Song
2007
Beads, thread, river rock

Visible Soul, Emerald
1995
Beads, thread, river rock,

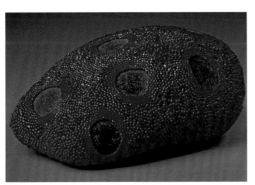 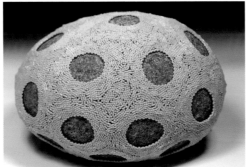 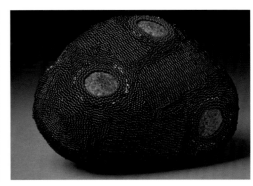

3 **Chris Allen-Wickler** Cranbrook Academy of Art, MFA, 1991

In the *Visible Souls* series, Chris Allen-Wickler encrusts riverbed rocks with intricate beadwork.
For Allen-Wickler, rocks are a link to the earth's past and due to their resiliency will exist well into the
future. Bearing gorgeous surfaces evoking hidden treasures, the works become metaphors for
"solitude, meditation, and accumulation."

Born 1959, Kingston, New York
University of Minnesota,
Minneapolis, BFA, 1982

Allen-Wickler lives in Lake Leelanau,
Michigan, and is a Co-Director of
The Art Place in Suttons Bay, Michigan.

4 **Paula Stebbins Becker** Cranbrook Academy of Art, MFA, 1993

Solstice and similar works by Paula Stebbins Becker comment on aspects of everyday life, the passage
of time and the erosion of memory. By unraveling and reweaving the cloth in this series and pairing it with
a photograph, Becker transforms an ordinary, mass-produced object into a springboard for narrative.
The image provides a visual catalyst while the worn cloth provides a tactile complement much like an
archaeological shard.

Born 1961, Leominster, Massachusetts
Southeastern Massachusetts University,
BFA, 1984

Becker lives in Tiverton, Rhode Island,
and is a Director of Design for Quaker
Fabric in Fall River, Massachusetts.

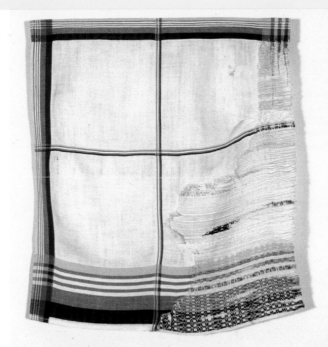

Solstice
1996
Unraveled and rewoven linen napkin,
silk (inlay), photograph

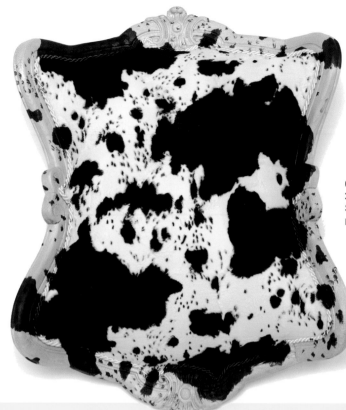

Cow
2004
Seatbacks, printed cotton cloth,
paint, foam, cord

5

Claire Begheyn Cranbrook Academy of Art, MFA, 1979

Nature, plants and animals provide the inspiration for Claire Begheyn, resulting in works that comment
on the ways in which contemporary Western society transforms plants and animals into ornamentation.
With *Cow*, Begheyn explores our dependence on animals for survival. Combining an animal print
textile with seatbacks from found chairs, associated with the human body, Begheyn wryly addresses
our appreciation for natural forms that often results in their exploitation.

Born 1950, Amsterdam, The Netherlands
Tilburg, The Netherlands, NS, BFA, 1972
Tilburg, The Netherlands, ND, BFA, 1974

Begheyn lives in Amsterdam,
The Netherlands.

6

Elizabeth Billings Cranbrook Academy of Art, MFA, 1989

From her days at Cranbrook to her latest projects in Vermont, Elizabeth Billings has expanded on her
appreciation of natural phenomena in traditional Japanese textiles. Recent work incorporates tree saplings
directly into her weavings. As the title and media for this work stress their direct tie to nature, the visual
rhythm of an EKG from a human heart is also evoked. Billings juxtaposes the basic forms of nature with
the sophistication of technological advancements.

Born 1959, Woodstock, Vermont
Earlham College, Richmond,
Indiana, BA, 1982

Billings lives in Tunbridge, Vermont.

Red Pine Walnut
2005
Woven cotton, red pine needles,
walnut stems

Venous Drainage of Head
2004
Silk fabric,
cotton/polyester thread

7

Beth Blahut Cranbrook Academy of Art, MFA, 1995

Born 1966, Detroit, Michigan
University of Wisconsin, Madison, BS, 1987

Blahut lives in New Glarus, Wisconsin.

The images of Beth Blahut's threadwork are drawn from medical imagery such as MRIs and instructional didactics. Her lacework explores our interconnected networks, not unlike the series of nerves, blood vessels and cells that constitute much of the human body. *Venous Drainage of Head* reveals our attempts to understand the underpinnings of the human structure through the aid of two equal forms of communication, imagery and the written word.

8

Sandra Brownlee Cranbrook Academy of Art, MFA, 1981

Born 1948, Fredericton,
New Brunswick, Canada
Nova Scotia College of Art and Design,
Halifax, Canada, BFA and Diploma in
Art Education, 1971

Brownlee lives in Dartmouth, Nova
Scotia, Canada, and teaches in the Textile
Department at the Nova Scotia College
of Art and Design University in Halifax.

Calligraphic Sea–Day and *Night* typify Sandra Brownlee's employment of a pictorial shorthand. *Night* suggests nature's mysterious forces discovered within a matrix of black and white threads. *Day* is more optimistic with a band of zoomorphic forms similar to those found in twelfth-century Peruvian textiles, announcing a lightness and innocence. These visually active compositions reinforce an emphasis on the rhythms of nature.

Calligraphic Sea–Day
1991
Supplementary weft pick-up,
mercerized cotton sewing thread

Calligraphic Sea–Night
1991
Supplementary weft pick-up,
mercerized cotton sewing thread

Domesticated Plant Series:
King Hoya and **Queen Hoya**
2006
Photography collage

9

Mira Burack Cranbrook Academy of Art, MFA, 2005

In the *Domesticated Plant Series*, Mira Burack reinterprets the relationship between people and their cultivated living forms. Starting with photographs, Burack carefully cuts apart the plant images and reorders the details into anthropomorphized, collaged compositions. The artist uses an evolved form, the houseplant, and through altered imagery refines it into the ironically revered order of royalty.

Born 1974, Boston, Massachusetts
Pepperdine University,
Malibu, California, BA, 1996

Burack lives in Bloomfield Hills, Michigan, and is a Collections Fellow for the Cranbrook Archives.

10

Carol Burns Cranbrook Academy of Art, MFA, 1985

With its title in Haitian Creole, *La Ren Nan Bwa* references the Vodou flags or *drapo* traditionally used to honor and call forth spirits during Vodou ceremonies. Carol Burns employs the painstaking sequin and beadwork of traditional flag makers while adding numerous small found objects to the central figure. The imagery and content of Burns's work depart from Vodou symbolism and become a personal artistic statement.

Born 1946, Cumberland, Maryland
The Pennsylvania State University,
University Park, BS, 1968
University of Northern Colorado, Greeley,
MA, 1979

Burns lives in Santa Fe, New Mexico.

La Ren Nan Bwa (Queen in the Woods)
2005
Stitched sequins, beads,
found objects

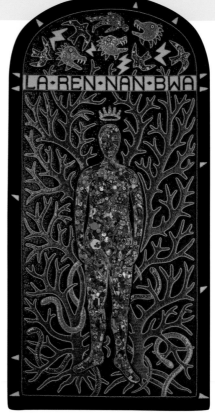

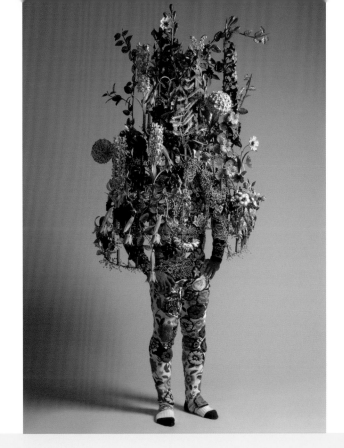

Soundsuit
2005
Mixed media

11
Nick Cave Cranbrook Academy of Art, MFA, 1989

Nick Cave's *Soundsuits* merge his diverse interests including fashion, dance, ritual, social identity and fiber. The *Soundsuits* are a culmination of an investigation, more than a decade long, into wearable sculptures that are named for the sounds they make when they are worn. Constructed of found objects and handmade elements, they are reminiscent of both African ceremonial costumes and haute couture. In the global environment they become sites for crossing boundaries of gender, race and class while exploring ceremonial concepts of culture.

Born 1959, Fulton, Missouri
Kansas City Art Institute, Missouri, BFA, 1982

Cave lives in Chicago, Illinois, where he is an Associate Professor and Chair of Fashion Design at The School of the Art Institute of Chicago.

12
Kyoung Ae Cho Cranbrook Academy of Art, MFA, 1991

Kyoung Ae Cho carefully selects organic material, such as the corn leaves in *Toward*, for her work. The artist planted and harvested the source corn, then pressed sections of the leaves and placed them between pieces of silk organza. Cho's working process enters into a harmony with nature, which is echoed in the delicate embroidery patterns that trace those of the leaves. *Toward* creates a field of energy both dense and light.

Born 1963, Onyang, South Korea
Duksung Women's University, Seoul, South Korea, BFA, 1986

Cho lives in Milwaukee where she is an Associate Professor for the Peck School of the Arts at the University of Wisconsin–Milwaukee.

Toward
2006
Corn leaves, silk
organza, thread

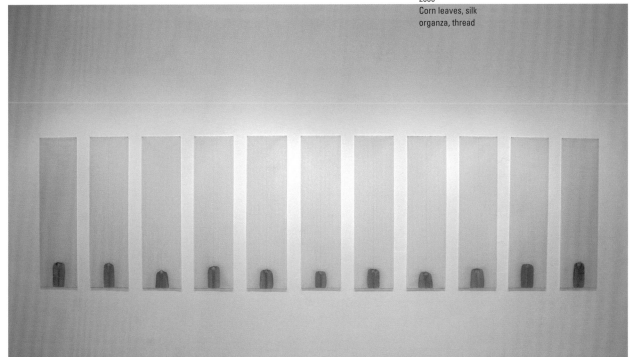

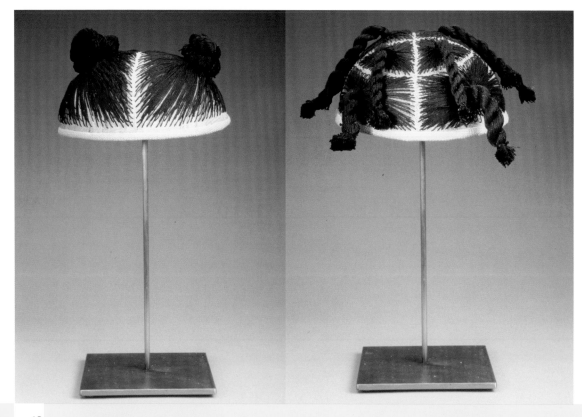

Hemi
1998
Cloth, crochet thread

Spider
1998
Cloth, crochet thread

13

Sonya Clark Cranbrook Academy of Art, MFA, 1995

Of Caribbean heritage, Sonya Clark draws on the traditions of West African textiles and hairstyles to make works that reference domestic and ceremonial objects. Clark's works raise subversive questions about their transformative power across the lines of culture, race and gender. *Spider* might endow its wearer with a new power, serve a mysterious ritualistic purpose, or subtly challenge stereotypes while speaking to the cultural formation of personal identity.

Born 1967, Washington, D.C.
Amherst College, Amherst,
Massachusetts, BA, 1989
The School of the Art Institute of Chicago,
Illinois, BFA, 1993

Clark lives in Richmond, Virginia, where she is a Professor and Chair of the Craft/Material Studies Department at Virginia Commonwealth University, School of the Arts.

14

Barbara Cooper Cranbrook Academy of Art, MFA, 1977

Barbara Cooper evokes the persistent processes of life in complex structures such as *Span*. The forms that comprise the work build upon and twist themselves around, reminiscent of the long-term endurance of trees, an idea which is underscored by her use of wood. Composed of many layers of veneer, the forms seem to organically evolve and expand, calling forth not only tree rings but tenacity and the slow accretion of years and experience.

Born 1949, Philadelphia, Pennsylvania
Cleveland Institute of Art, Ohio, BFA, 1974

Cooper lives in Chicago, Illinois, where she is a member of the Adjunct Faculty, Continuing Studies Program, at The School of the Art Institute of Chicago.

Span
2003
Wood, glue

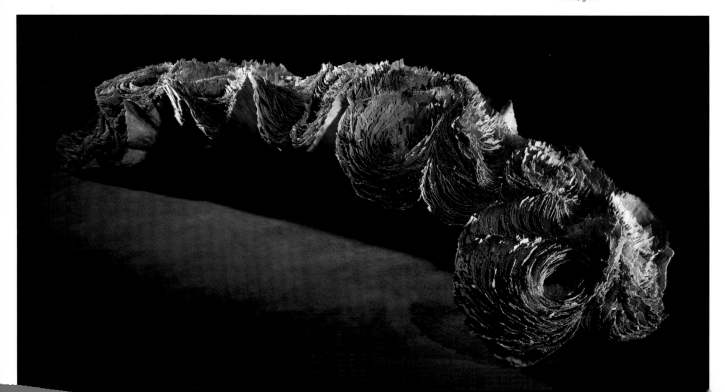

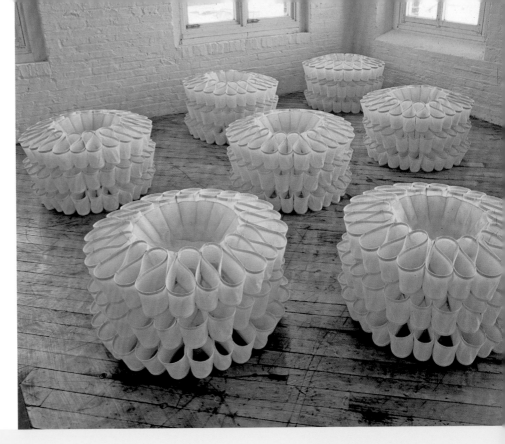

Act Normal and That's Crazy Enough
2002
Starched cotton, reed, copper wire, computer
embroidery, fabric

15 Annet Couwenberg Cranbrook Academy of Art, MFA, 1986

Annet Couwenberg draws on early impressions of her mother's sewing circle and their Dutch background for her set of seven stacked ruffled forms. *Act Normal and That's Crazy Enough*, a Dutch proverb, evokes the collars familiar from seventeenth-century Dutch portraits. Couwenberg transforms their scale, stacks the units, and embroiders within each piece one word of the title, all of which takes them out of the realm of clothing and into that of fiber sculpture.

Born 1950, Rotterdam, The Netherlands
School for Textiles, Rotterdam,
The Netherlands, BFA, 1974
Syracuse University, New York, MFA, 1983

Couwenberg lives in Baltimore, Maryland,
where she is the Chair of the
Fiber Department at the
Maryland Institute College of Art.

16 Julie Custer Cranbrook Academy of Art, MFA, 2003

Julie Custer creates site-specific installations that explore the perception of ordinary materials in a harmonious, if unexpected, relationship to each other. While the installation's palette is restricted and its marks subtle, the artist has activated a modest space and introduced surface textures that defy easy classification. Custer uses thread to create crystalline forms that seem to uncannily emerge before the viewer.

Born 1970, Kansas City, Kansas
University of Kansas, Lawrence, BFA, 1993

Custer lives in Seattle, Washington.

Thread
2006
Thread, drywall, paint

Compact
from the Outlook Series
2006
Found compact,
photographic decal

17 Christina P. Day Cranbrook Academy of Art, MFA, 2006

Christina Day's work concerns exploration into memory, history and nostalgia. The found objects in the Outlook Series invite speculation into their uses and the lives of their previous owners. In this example of a compact case and mirror, its reflective quality, meant for intimate inspection, is layered with a photographic image evoking other times and places. The object addresses an unknowable past and serves as a vehicle of absence and longing.

Born 1977, Ridgewood, New Jersey
University of the Arts, Philadelphia,
Pennsylvania, BFA, 1999

Day lives in Philadelphia, Pennsylvania,
where she works in the field of historic
preservation and teaches in the Fiber
Department at the University of the Arts.

18 Kristen Dettoni Cranbrook Academy of Art, MFA, 1993

Zero Impact is one of many sustainable products designed, engineered and manufactured for automotive upholstery. InterfaceFABRIC, for which Kristen Dettoni produced this work, attempts to minimize its impact on the environment while presenting products that appeal to traditional sensibilities. *Zero Impact* has a long repeat, allowing for nonspecific cutting for each individual seat. This creates less waste in the cutting process and provides each seat with a unique identity while still maintaining overall pattern continuity in the vehicle.

Born 1969, Boston, Massachusetts
Kansas City Art Institute,
Missouri, BFA, 1991

Dettoni lives in New York City where she is
a Senior Designer for InterfaceFABRIC.

Zero Impact
2006
Post-consumer polyester
(made from recycled
soda bottles)

InterfaceFABRIC,
New York, New York
(Manufacturer)

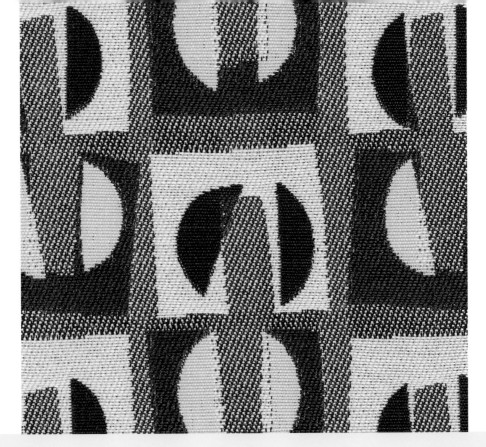

Unhinged
Designed 1999;
released 2001
Rayon, polyester, Woven
Crypton® finish

Momentum Textiles,
Irvine, California
(Distributor)

19

Robyn Dunbar Cranbrook Academy of Art, MFA, 2000

Unhinged, consisting of two semi-circles and vertical elements set within squares that tilt and open to the background, was inspired by Turkish tile work. Robyn Dunbar has remarked that this design grew out of her exploration of tile arrangements that when shifted and overlapped, produced a pattern of motion. Elegant in its simplicity, *Unhinged* has been used as upholstery in hotels, offices and other outlets.

Born 1972, Montréal, Canada
Skidmore College, Saratoga Springs,
New York, BS, 1993

Dunbar lives in Austin, Texas,
where she is a Design Director for
Sunham Home Fashions.

20

Layne Goldsmith Cranbrook Academy of Art, MFA, 1979

With an elegant, geometric pattern, Layne Goldsmith's *Linewalk* harkens back to Eliel and Loja Saarinen's architectural and design patterns, which are ubiquitous on Cranbrook's campus. Perhaps most striking is the manner in which Goldsmith has captured the essence of the Saarinens' scale, rhythm and understated color as seen in the first generation Saarinen textiles from the early 1930s.

Born 1950, Long Beach, California
California State University, San José, BA, 1972
California State University, San José, MA, 1975

Goldsmith lives in Snohomish, Washington,
and is a Designer and Partner at Dorjé
Contemporary, LLC, in Seattle, Washington.
She is also a Professor of Art in the Fibers
Program at the School of Art, University
of Washington in Seattle.

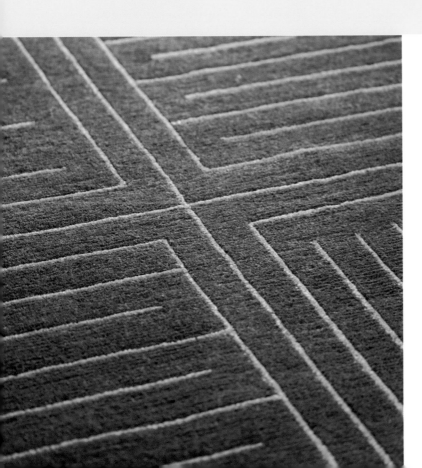

Linewalk
2007
Tibetan wool

Layne Goldsmith and
Rachel Meginnes (Designers)
Dorjé Contemporary, LLC, Seattle,
Washington (Manufacturer)

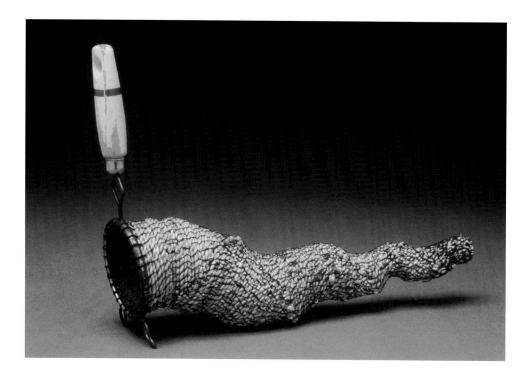

Crawl
2001
Sea grass, linen thread,
found object

21 **Rita Grendze** Cranbrook Academy of Art, MFA, 1994

Like early Dada works, but with more humor and insouciance, Rita Grendze transforms a common domestic object into something unexpected and delightful. The ordinary kitchen sieve remains recognizable, yet at the same time it becomes a whimsical organic form. Both familiar and yet utterly not, Grendze's inventive work draws forth an uncanny feeling from the viewer.

Born 1964, Altona, Manitoba, Canada
Cleveland Institute of Art, Ohio, BFA, 1987

Grendze lives in Geneva, Illinois.

22 **Marcie Miller Gross** Cranbrook Academy of Art, MFA, 1990

Hospital towels speak a new language when carefully folded, stacked and configured within the context of an art museum. The artist has juxtaposed the familiar towel with a history of abstraction, especially Minimalist, geometric form, seen in the context of architecture. The goal is to suggest an interdependence of fabric form with architecture and space, and to establish a poetic condition wherein the softness of fabric transforms into a new visual sensation.

Born 1958, Kansas City, Kansas
University of Kansas, Lawrence, BFA, 1982

Miller Gross lives in Kansas City, Missouri, where she is an Adjunct Faculty member at the Kansas City Art Institute.

Intersection
2005
Cotton huck towels,
basswood

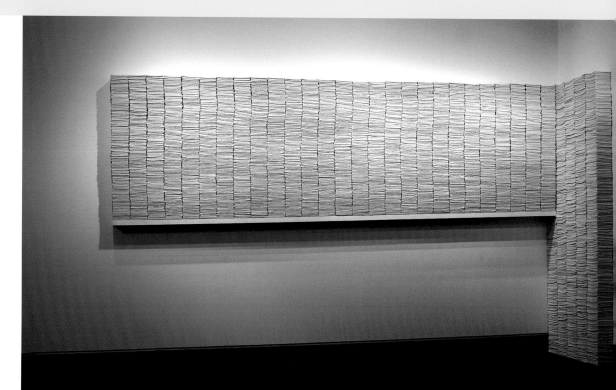

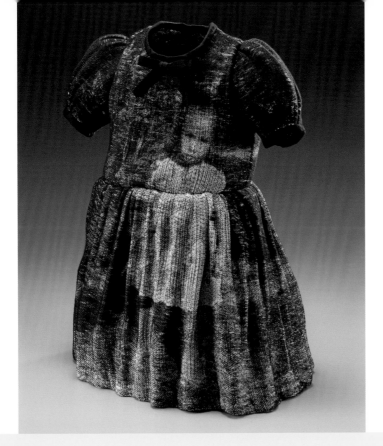

A Little Dress
2005
Polyester, metal (jacquard weave)

23

Wen-Ying Huang Cranbrook Academy of Art, MFA, 1993

The imagery of *A Little Dress* derives from the earliest photograph that Wen-Ying Huang can remember being snapped of her. The work is a physical manifestation of that memory using, in part, the form of the shirt that the artist wore in the early photograph. *A Little Dress* is also about the form of the body and its role as a container, metaphorically and physically, a subject that she has extensively explored in the context of her culture.

Born 1960, Chunghua County, Taiwan
National Taiwan Normal University,
Taipei, B Ed, 1982
University of Iowa, Iowa City, MA, 1990

Huang lives in Kuan-tien, Taiwan, and is an Associate Professor at the Graduate Institute of Applied Arts, Tainan National University of the Arts, Taiwan.

24

Hiroshi Jashiki Cranbrook Academy of Art, MFA, 1983

While Hiroshi Jashiki has had extensive commercial success in fashion and apparel design, his latest body of work is in the field of digital art facilitated by textile software. The rich, saturated color and transparency of printing pigments produces effects similar to the interaction of dyes on fabrics. These fantasy abstractions, born in the realm of new technology, reflect the sensitivity of a master dyer who has discovered new ways of materializing his vision.

Born 1954, Okinawa, Japan
Ryukyu University, Naha,
Okinawa, Japan, BFA, 1978

Jashiki lives in New York City and teaches a textile design course at the Okinawa Prefectural University of Arts in Shuri Naha, Japan, every other year.

Fragments 1
2006
Digital print

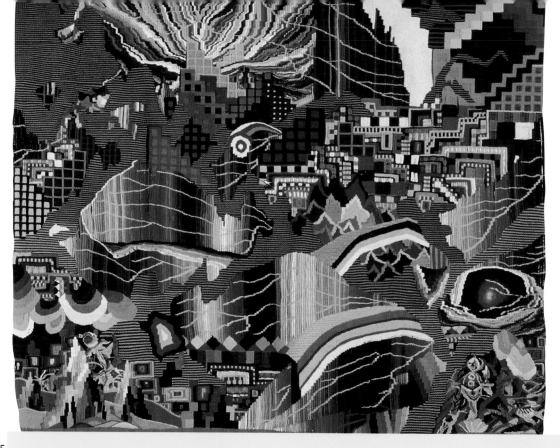

Meltdown
1986
Wool and cotton tapestry

25 Geary Jones and David Johnson Cranbrook Academy of Art, MFAs, 1981

Like jazz musicians, Geary Jones and David Johnson blended their different styles through improvisatory collaboration on the weaving loom for the tapestry *Meltdown*. Their constant dialogue, both verbal and visual, produced a synergistic effect in which contrasting color sensibilities combine to achieve a harmonious composition of an ominous subject. *Meltdown* refers to the folly of building nuclear power plants along the Columbia River Gorge, which sits on a major fault line.

Geary Jones, born 1953, Grand Rapids, Michigan
University of Michigan, Ann Arbor, BFA, 1978

Jones lives in Grand Rapids, Michigan.

David Johnson, born 1956, Denver, Colorado
Colorado State University, Fort Collins, BFA, 1978

Johnson lives in Thornton, Colorado.

26 Mary Anne Jordan Cranbrook Academy of Art, MFA, 1985

Mary Anne Jordan's work is built on geometric compartmentalized structures, familiar in traditional quilts, which are placed in tension with visual conditions that refuse to be limited or harnessed. The artist allows dyes to transgress borders and boundaries, generating visual osmosis and a strong sense of the process, like the breathing that accompanies life. The fabric seems thirsty for the liquid dye it absorbs, and the language of pattern is enhanced with the natural deviations.

Born 1957, Toledo, Ohio
University of Michigan, BFA, 1981

Jordan lives in Lawrence, Kansas, where she is an Associate Professor of Design at the University of Kansas.

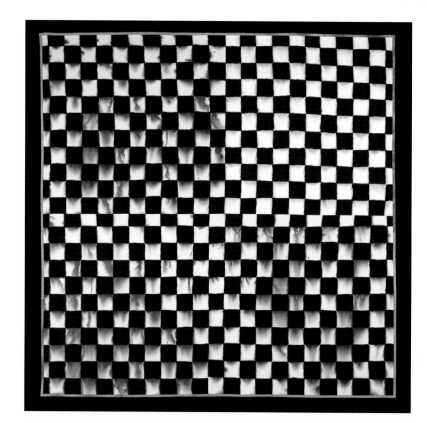

One Patch Variation
2006
Dyed fabric (pieced and quilted)

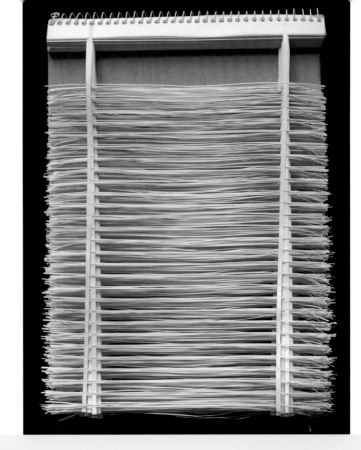

Tablet
2005
Modified tablet of
notebook paper

27 **Sarah Kabot** Cranbrook Academy of Art, MFA, 2002

Born 1976, Royal Oak, Michigan
University of Michigan,
Ann Arbor, BFA, 1998

Kabot lives in Cleveland, Ohio,
where she is an Assistant Professor at
The Cleveland Institute of Art.

In *Tablet*, Sarah Kabot has used an ordinary spiral notebook and removed all of the white spaces leaving the thin blue structural lines intact. Through this subtractive process, Kabot reveals paper as a basic form of fiber with an underlying structure and multiple strands ready to be rejoined. On a psychological level, the work simultaneously comments on substance, function, perception and form.

28 **Emily Keown** Cranbrook Academy of Art, MFA, 2005

Born 1980, Blacksburg, Virginia
Maryland Institute College of Art,
Baltimore, BFA, 2002

Keown lives in Blacksburg, Virginia,
and is an Adjunct Faculty member in the
Art Department at Radford University
in Radford, Virginia.

Emily Keown employs a handkerchief to explore gender issues with gentle irony. In *Defense Strategies Part II a*, Keown embroidered a cartoon girl on a linen handkerchief with lacy edging along with the repeated sentence, "There is just something in my eye." Both comic and pathetic, Keown poignantly freights the delicacy of the handkerchief with the defense strategies of the vulnerable.

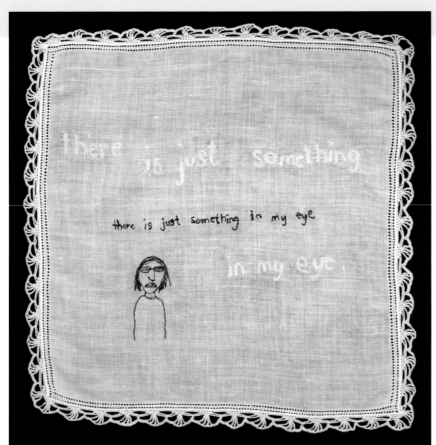

Defense Strategies Part II a
2006
Embroidery on found handkerchief

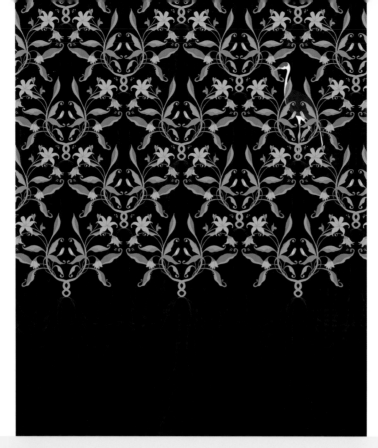

Bayou (Night)
2005
Digital print on paper

29 **Wook Kim** Cranbrook Academy of Art, MFA, 2002

In his wallpaper designs, Wook Kim produces intricate patterns with an occasional surprise.
His principal concern is the activation of space in unexpected ways. While Kim designs wallpaper with
repeating patterns, through the positioning of fanciful animals, in this case a crane, the appearance
can be customized for each installation.

Born 1974, Seoul, South Korea
Rhode Island School of Design,
Providence, BFA, 1996

Kim lives in New York City.

30 **Jessica Kincaid** Cranbrook Academy of Art, MFA, 1999

Jessica Kincaid's *Heaven and Earth* was inspired by her dreams of a place "where everyone in the building
lived alone and no one felt lonely," a subject reinforced for the artist when she saw pictures of Lhasa, Tibet,
which means "place of the gods." The dreamy, visionary quality of the image is reinforced by the reflective
nature of the beads that seem to dissolve the image before our eyes. *Heaven and Earth* is exceptional for the
artist in that it is not part of a series, yet Kincaid worked on it for twenty years until its resolution in 2006.

Born 1970, Lexington, Kentucky
Kansas City Art Institute, Missouri,
BFA, 1992

Kincaid lives in Overland Park, Kansas,
where she is a special education
paraprofessional for the Blue Valley
School District

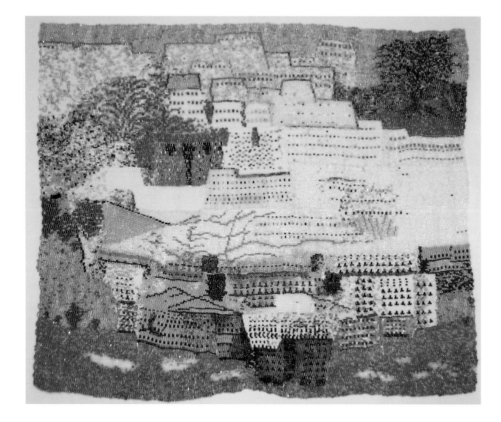

Heaven and Earth
2006
Glass beads, silk thread

31

Libby Kowalski Cranbrook Academy of Art, MFA, 1981

The daughter of a Czech-trained seamstress, Libby Kowalski used the forms and reflective quality of crystal vases and chandeliers from her ancestry as the inspiration for her recent line of synthetic, commercial fibers. Kowalski succeeded in developing a translucent material that acts like etched glass yet functions as a textile. The resulting line, the Krystal Weave SatinFR collection, has been successfully adapted for window treatments and room dividers in commercial and domestic projects.

Born 1940, Chicago, Illinois
Millikin University, Decatur, Illinois, BA, 1961
Colorado State University, Fort Collins, BFA, 1979

Kowalski lives in New York City where she directs Kova Textiles LLC, a company she formed with her son, Gregory Kowalski, in 2004, and the CTD Studio, a freelance textile design studio. She also is a Professor Emeritus at State University of New York at Cortland.

32

Andrea Gaydos Landau Cranbrook Academy of Art, MFA, 2005

In *Arcana*, Andrea Gaydos Landau constructs a horizontal lattice of by-products from our daily activity. By gathering dust and residues she explores profane and sacred boundaries of material choices in art, which is mirrored conceptually. Landau's work references systems of accumulation and deterioration. With a careful arrangement of particles her work challenges notions of beauty and encourages us to reflect on the passage of time.

Born 1979, Allentown, Pennsylvania
The Cleveland Institute of Art, BFA, 2002

Landau lives in Philadelphia, Pennsylvania, where she is a Construction Technician for The Fabric Workshop and Museum.

Arcana
2007
Glass, mirror,
residue and dust

Trans-bared
1998
Kitchen towel, hair, wax

Mi-Kyoung Lee Cranbrook Academy of Art, MFA, 1998

Trans-bared is a sculptural amalgam of bookmaking and fiber, two fields that Mi-Kyoung Lee has studied in depth. *Trans-bared* might be considered a living journal with marks and holes, each a "moment of repetition" that collectively form a porous, translucent surface. Built with layers, including multiple strands of hair, *Trans-bared* is both a solemn text and a breathing organism.

Born 1970, Kyung-nam, South Korea
Dong-A University, Pusan, South Korea,
BFA, 1993
The University of the Arts, Philadelphia,
Pennsylvania, MFA, 1996

Lee lives in Philadelphia, Pennsylvania,
where she is the Head of the Fibers/Crafts
Department at The University of the Arts.

Anne Lindberg Cranbrook Academy of Art, MFA, 1988

With titles that incorporate evocative words such as "float," "cloud," "mass" and "breathing," Anne Lindberg's recent work references the systems and rhythms of nature and the mind. *white cloud*'s countless steel wires hold their position on the wall, yet sway in concert, their responsiveness evoking complex systems such as wind, prairie, body rhythms and consciousness. Lindberg's work blends fiber, sculpture and drawing, reflecting the vast orders of phenomena.

Born 1962, Iowa City, Iowa
Miami University, Oxford, Ohio, BFA, 1985

Lindberg lives in Kansas City, Missouri,
where she maintains her studio and also
is the owner of Derek Porter Studio for
architectural lighting design.

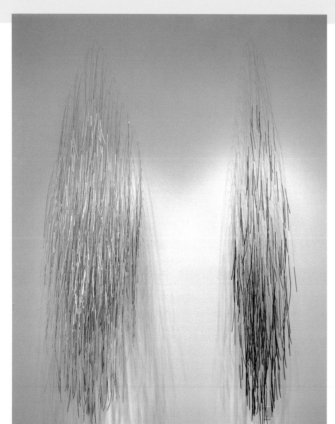

white cloud
2005
Stainless steel wire,
pine, acrylic

shadow cloud
2005
Stainless steel wire,
pine, graphite

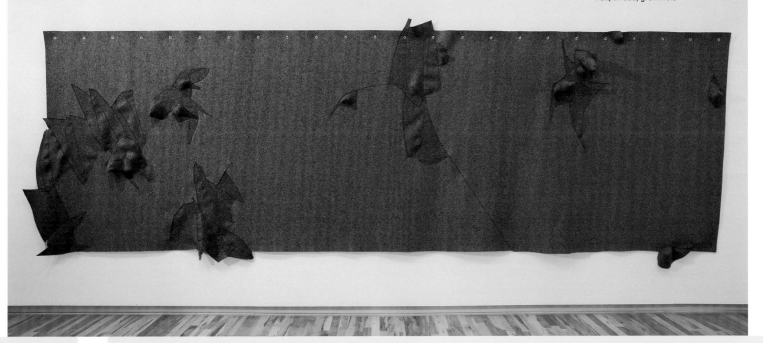

Migration 6.83
2005
Felt, thread, grommets

35 Joan Livingstone Cranbrook Academy of Art, MFA, 1974

Joan Livingstone's Migration series continues the artist's exploration of natural systems ranging from monumental landscapes to modest changes on the surface of skin. In *Migration 6.83*, the topography of felt is interrupted with irregularities that shift in meaning. Surface associations arise that lead to unexpected connections. The surface may shift from a macro to a micro world rich with external associations, or may exist for its own sake, like the hide of an elephant.

Born 1948, Portland, Oregon
Portland State University, Oregon, BFA, 1972

Livingstone lives in Chicago, Illinois, where she is the Chair of the Undergraduate Division and a Professor of Fiber and Material Studies at The School of the Art Institute of Chicago.

36 Lisa Lockhart Cranbrook Academy of Art, MFA, 1983

Lisa Lockhart likes to collect objects from auctions, estate sales and her village dump. In *Oval Level* she gives new dimension and possibility to once utilitarian objects that have been stripped and separated from their primary function. The components of this work create a unified sculptural presence through repetition, while simultaneously confounding the original function of the objects that inspired Lockhart's response.

Born 1959, Rockford, Illinois
The School of the Art Institute of Chicago, Illinois, BFA, 1981

Lockhart lives in Onarga, Illinois.

Oval Level
2002
Mixed media,
vintage levels

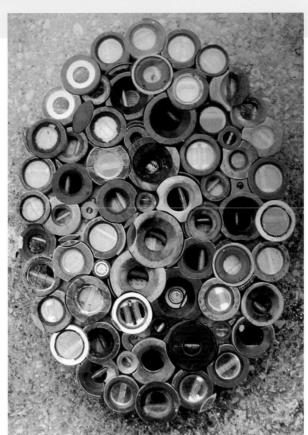

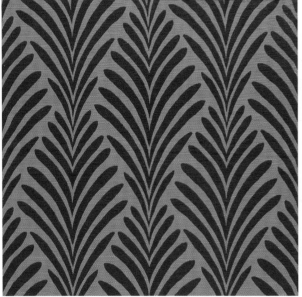

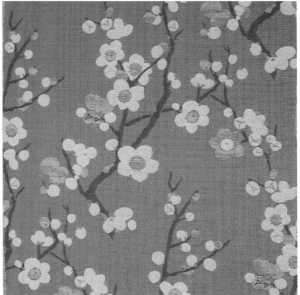

Amboro (Kiwi)
Designed 2005; released 2006
Rayon
Home Fabrics, Connelly Springs,
North Carolina (Manufacturer)

Cherry Blossom (Pear)
Designed and released 2006
Rayon, polyester, cotton, nylon
Valdese Weavers, Valdese,
North Carolina (Manufacturer)

37 Wesley Mancini Cranbrook Academy of Art, MFA, 1977

For Wesley Mancini, design is "creating a product with someone else in mind." The qualities of drawing, colors, yarns and weaving must be balanced with an eye toward cost and taste. Two successful commercial projects include *Cherry Blossom*, which draws on the aesthetic influence of Japanese screens, and *Amboro*, with its stylized botanical motif. In these and other projects, Mancini references elements of historical textiles for contemporary applications.

Born 1952, Reno, Nevada
Philadelphia College of Art,
Pennsylvania, BFA, 1974

Mancini lives in Charlotte, North Carolina, where he is the owner and President of Wesley Mancini, Ltd.

38 Fuyuko Matsubara Cranbrook Academy of Art, MFA, 1984

In *The Lights*, Fuyuko Matsubara has created a tangible image of the universal power that she believes cannot be seen, namely the energy sources that generate life. Employing a symbolic vocabulary, the circular lights seen in her work represent positive, infinite energy. Matsubara employs a complex crepe weave and masterful dyeing techniques to produce an inviting illusionary space beyond reality.

Born 1955, Sapporo, Japan
Musashino Art University,
Tokyo, Japan, BA, 1978
Musashino Art University,
Tokyo, Japan, MA, 1980

Matsubara lives in Indiana, Pennsylvania, where she is an Associate Professor at Indiana University of Pennsylvania.

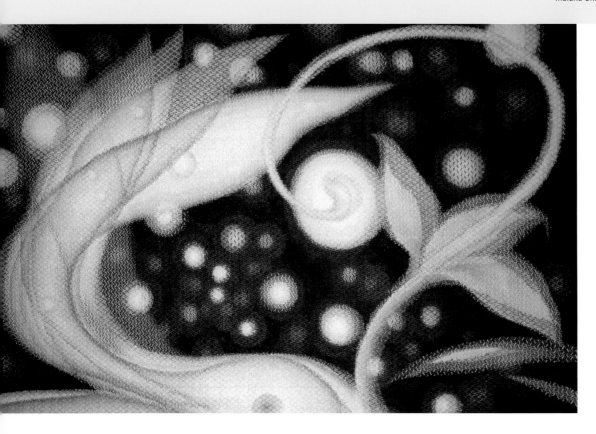

The Lights
1997
Hand-plied yarn (linen, cotton, rayon, silk), fiber reactive dyes

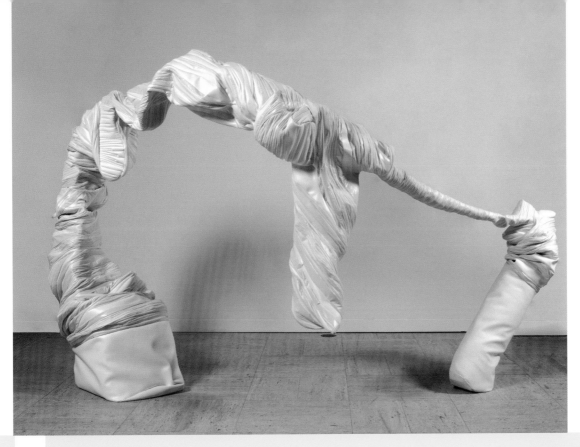

Relinquish
2007
Fabric, zippers, wood

39 **Abbie Miller** Cranbrook Academy of Art, MFA, 2007

Between the labor-intensive techniques of clothing construction and the possibilities of drawing, Abbie Miller works out the conceptual ideas for her fiber sculpture. In *Relinquish*, the long piece of fabric "zips" into its shape, evoking the human body as both form and expressive vehicle yet producing something previously unimagined.

Born 1981, Billings, Montana
University of Wyoming, Laramie, BFA, 2004

Miller is an Instructor for the Cranbrook Summer Art Institute.

40 **Kristen Miller** Cranbrook Academy of Art, MFA, 1993

Kristen Miller's stitched wrapper series, including *Jet Black with a Blue Bloom*, makes strong associations to the growth process of young trees. The dense stitching in the core of the works evokes the seeds they produce, while the outward concentric circles resemble their thin growth bands or annual rings. *Jet Black with a Blue Bloom* calls to mind the special wonders of nature traced onto a piece of wrapping paper that once protected a piece of fresh fruit.

Born 1963, Kansas City, Kansas
University of Kansas, Lawrence, BFA, 1987

Miller lives in Portland, Oregon.

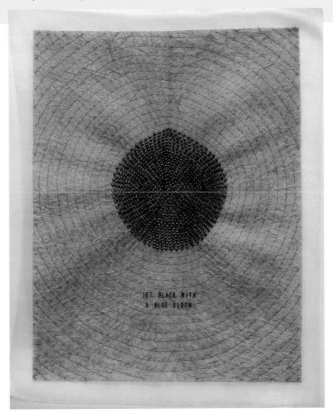

Jet Black with a Blue Bloom
2006
Cotton organdy, fruit wrapper, silk thread, 22k white gold beads

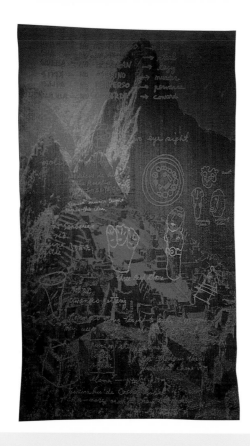

**Diary from the Andes/
Machupicchu**
2004
Cotton (jacquard weave)

41 Emiko Nakano Cranbrook Academy of Art, MFA, 1987

Emiko Nakano's fascination with Peruvian culture began while trekking in the Andes and visiting indigenous people. The discovery that their traditional beliefs and mythology intersected with her own Japanese heritage became a source of inspiration for her work. Using the jacquard loom to weave an image of Machupicchu and a page from her Peruvian diary into the matrix of a contemporary textile, Nakano reflects on the handmade cloth of ancient Peruvians.

Born 1941, Tokyo, Japan
Rikkyo University, Tokyo, Japan, BA, 1964
Tokyo Zokei University, Japan, BFA, 1975

Nakano lives in Tokyo, Japan, where she is a Professor in the Design Department at Tokyo Zokei University.

42 Abigail Anne Newbold Cranbrook Academy of Art, MFA, 2005

Abigail Newbold's *At Home* and her new installation for the *Hot House* exhibition, *Making Home*, raise questions about the components that constitute the very concept of "home" by displaying the process of making a quilt, one of our oldest cultural signifiers of comfort and belonging. The quilt is integrated within a domestic environment that is hung on the wall for analysis, inviting dispassionate reflection about this fundamental yet often unexamined aspect of life.

Born 1976, Boston, Massachusetts
Massachusetts College of Art,
Boston, BFA, 2002

Newbold lives in Detroit, Michigan, and is the Preparator for Cranbrook Art Museum.

At Home
2005
Building materials, paint, furnishings, light, wheels, oak flooring, maple table, linen and cotton quilts

Villa Farsetti: The Greenhouse #2
1984
Wool, cotton, silk

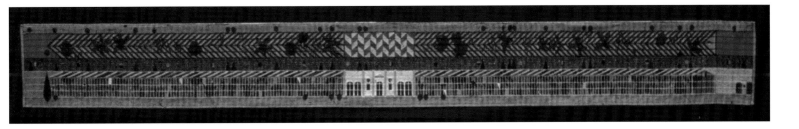

43 **Laura Foster Nicholson** Cranbrook Academy of Art, MFA, 1982

Villa Farsetti: The Greenhouse #2 is part of a four-part tapestry cycle that Laura Foster Nicholson created for the 1985 Venice Biennale of Architecture. Nicholson's work was inspired by the gardens of Cranbrook and the flat, patterned depiction of architecture and landscape in the textiles of Loja Saarinen. Built line by line, one is reminded of the rhythm of a walk in the landscape in which there is time to reflect and notice details.

Born 1954, Waukegan, Illinois
Kansas City Art Institute,
Missouri, BFA, 1976

Nicholson lives in New Harmony, Indiana, where she directs LFN Textiles Studio.

44 **Ólöf Nordal** Cranbrook Academy of Art, MFA, 1991

Ólöf Nordal's *Iceland Specimen Collection* presents one of the oldest sources of fiber: the lamb in its natural environment. Closer inspection of the photographic triptych, however, reveals frozen, taxidermic specimens with rare deformities. Nordal addresses the ominous results of human intervention that affect the animal world. The aberrations also inspire reflection on sources of mythological creatures that capture human imagination with their ability to inhabit our world in believable ways.

Born 1961, Copenhagen, Denmark
Icelandic College of Art and Crafts,
Reykjavík, Diploma, 1985
Yale University School of Art, New Haven,
Connecticut, MFA, 1993

Nordal lives in Reykjavík, Iceland, where she is an Instructor at both the Iceland Academy of the Arts and The Reykjavík Art School.

**Iceland Specimen Collection –
Sleipnir, Cyclops, Janus**
2003
Three C-Prints

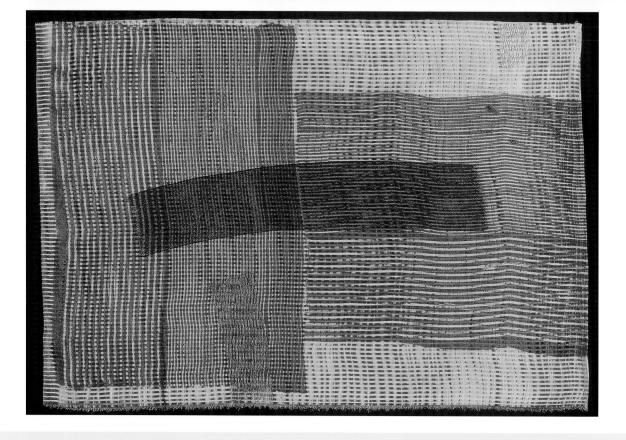

Fated
2004
Silk, cotton, nylon, pigment (stitched and printed construction)

Michael Olszewski Cranbrook Academy of Art, MFA, 1977

Michael Olszewski's elegiac fiber construction *Fated* creates the impression of a contemplative environment inhabited by abstract shapes. Evoking the presence of his mother's long struggle with Alzheimer's disease and inevitable death, this meditation on impending loss conveys a sense of history in its layered markings, its understated forms suggesting an accrual of events over time.

Born 1950, Baltimore, Maryland
Maryland Institute College of Art, BFA, 1972

Olszewski lives in Philadelphia where he is a Professor of Textile Design at the Moore College of Art and Design.

46

Erin Shie Palmer Cranbrook Academy of Art, MFA, 1993

Erin Palmer looks to the associative, physical and expressive qualities of materials for sensory-based reactions. *Shroud* is part of an on-going series entitled "O-Yoroi: Armor of the Soul." Its substance (copper) suggests architectural structure conceived for eternity, but its material lightness and construction reveal its physical frailty and point to the power and fallibility of the human belief in the ability to protect.

Born 1957, Flint, Michigan
University of Michigan, Ann Arbor, BS, 1978
University of Michigan, Ann Arbor, MArch, 1980

Palmer lives in Seattle, Washington, where she maintains a practice of public art commissions, studio work and architecture.

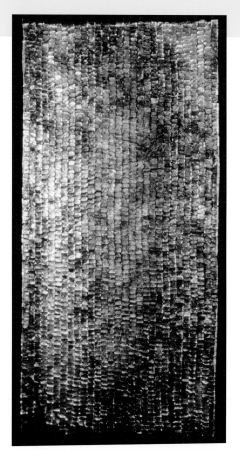

Shroud
1992
Copper, silk, cotton thread

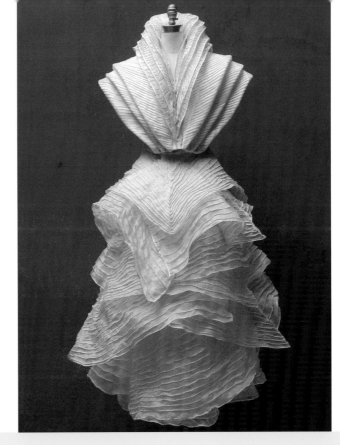

Lotus in the Clouds
2007
Woven organza (structured
and layered)

47 **Kinnari Panikar** Cranbrook Academy of Art, MFA, 1985 and **John Panikar**

The pleats, fold, drape and movement of the traditional Indian sari inspire designers Kinnari and John Panikar to invent new ways to reform the body with cloth. Skillful in creating works with a "transformational energy," their garments such as *Lotus in the Clouds* provide the wearer with an environment of tactile sensations that inspire elegant movement, posture and presence.

Kinnari Panikar, born 1948, Ahmedabad, Gujarat, India

John Panikar, born 1952, Kerala, India
National Institute of Design, India, 1979

The Panikars live in Ahmedabad, India, and New York City where they are the owners of Kinnu.

48 **Sina Pearson** Cranbrook Academy of Art, MFA, 1972

Bounce is one of hundreds of commercial textile patterns produced by Sina Pearson Textiles that have found homes in corporate, healthcare, hospitality and domestic environments. Woven with a unique yarn that uses only nontoxic chemicals and is entirely compostable, the works are always environmentally sound and visually compelling. This design takes its title from the kinetic effect of the stripes that visually dance with color, proportion, pattern and texture.

Born 1948, Seattle, Washington
University of Washington, Seattle, BA, 1970

Pearson lives in New York City where she is the owner of Sina Pearson Textiles.

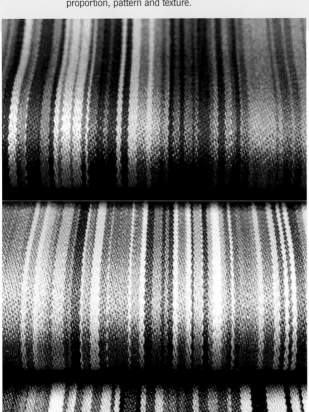

Bounce
2003
Wool, ramie

Sina Pearson Textiles,
New York, New York (Distributor)

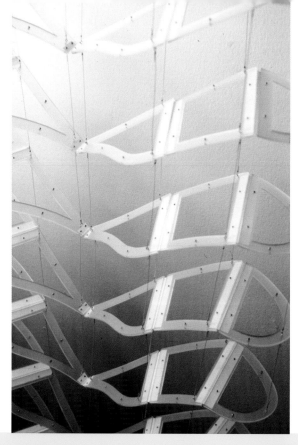

Study for a Flying Machine
2004
Welded steel, laser-cut plastic,
motor, battery, elastic,
jewelers' wire, brass hardware,
Tyvek hinges

49 Helen Quinn Cranbrook Academy of Art, MFA, 2000

Inspired by automata, fair rides and mechanical orchestras, Helen Quinn explores the beauty of movement in her sculptural works. Her machines imitate natural movements including flying, breathing, walking, and the pattern of waves and rain. While emulating natural phenomena, Quinn notes that the construction *Study for a Flying Machine* is a personal investigation into the "elusive presence of grace."

Born 1969, Washington, D.C.
Rhode Island School of Design,
Providence, BFA, 1991

Quinn lives in New York City where she is Director of Textile Design and Development at Q Collection.

50 Rowland Ricketts, III Cranbrook Academy of Art, MFA, 2005

Informed by years of experience in Japan as an indigo dyer, Rowland Ricketts gathers and cultivates plants and utilizes traditional methods of extracting their color for transfer dyes. Ricketts strives to produce colors so rich that the viewer connects to the deeper histories embodied by the plants from which those colors came —histories of place and interactions with humans, as well as their cultural and historical connections to those who have worked within these textile traditions.

Born 1971, Manchester, Connecticut
Wesleyan University, Middleton,
Connecticut, BA, 1993

Ricketts lives in Bloomington, Indiana, where he is a Visiting Assistant Professor of Textiles at the Henry Radford Hope School of Fine Art, Indiana University.

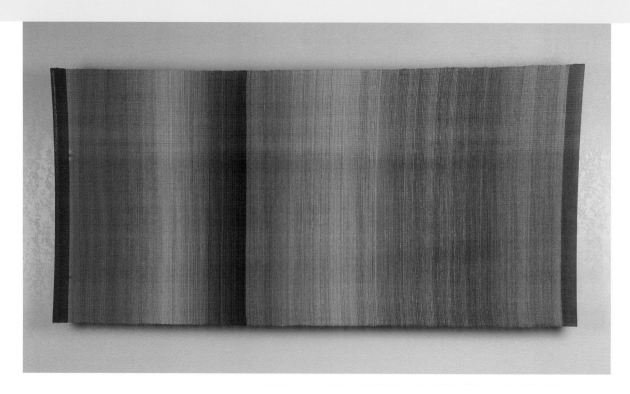

Untitled
2006
Silk and paper dyed with
native North American plants
(plain weave)

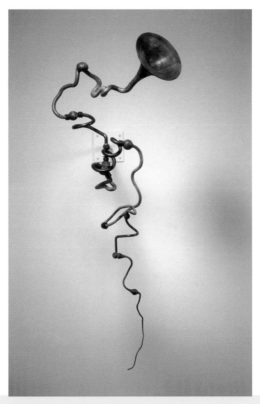

Ear Trumpet XXXXVIII
2003
Steel, wood

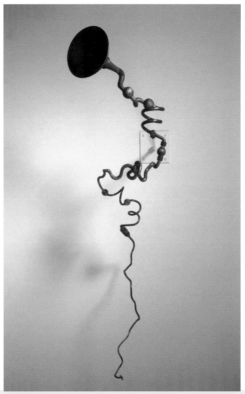

Ear Trumpet XXXIV
2003
Steel, wood

51
Jann Rosen-Queralt Cranbrook Academy of Art, MFA, 1976

Jann Rosen-Queralt creates sculptural sound works that require audience interaction and encourage discovery, collaboration and communication. Her *Ear Trumpets*, constructed of steel and wood, allow people to listen to their environment, heightening their awareness of voice —words, rhythm and language— as well as their sense of place and their own positioning within it.

Born 1951, Detroit, Michigan
Syracuse University, New York, BA, 1974

Rosen-Queralt lives in Baltimore, Maryland, where she is the owner of Jann Rosen-Queralt, Inc., and a Professor in the Interdisciplinary Sculpture Department and the Master of Community Arts Program of the Maryland Institute College of Art.

52
Judi Ross Cranbrook Academy of Art, MFA, 1995

Judi Ross admires early collectors and artists who traveled far and wide to gather natural specimens of butterflies, but appreciates the technology and resources that place journeys of discovery at our fingertips today. Ross's meditation on the regenerative power of nature is the video *Papilio*, in which she fuses scientific knowledge and artistic interpretation based on her research into physiology, flight pattern, collecting, mythology and the beauty of patterned fields of butterflies.

Born 1954, Jacksonville, Texas
Kansas City Art Institute, Missouri, BFA, 1991

Ross lives in Oaxaca de Juárez, Mexico, and Champaign, Illinois, where she is an Assistant Professor at the University of Illinois at Urbana-Champaign.

Papilio
2006
Still from video

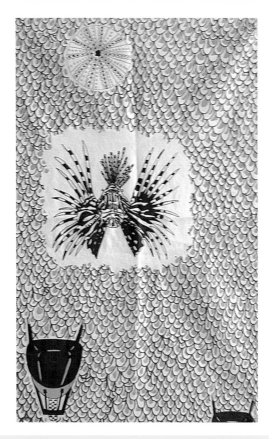

Fish Scale
2006
Cotton duck (screen-printed)

53 **Lauren Rossi** Cranbrook Academy of Art, MFA, 2006

The inspiration for Rossi's fabric design *Fish Scale* comes from the sea and the beach, with a wheelbarrow thrown into the mix, all reinterpreted into bold patterns and shapes. Rossi uses her upholstery fabrics to recycle and transform outmoded furniture into works with a renewed spirit. Her blend of vibrant, playful textile design and vintage furniture is colorful, compelling and sustainable.

Born 1980, Santa Barbara, California
Scripps College, Claremont, California, BFA, 2002

Rossi lives in Philadelphia, Pennsylvania.

54 **Arturo Alonzo Sandoval** Cranbrook Academy of Art, MFA, 1971

The fiber work of Arturo Alonzo Sandoval is distinguished by his use of contemporary industrial materials, which he began to explore and recycle during the 1970s. In *Pattern Fusion No. 1*, Sandoval employs concepts related to the art quilt form and process, which evolved from earlier explorations in his Cityscape series. Sandoval's work appropriates the industrial waste of modernity to produce seductively reflective, abstract works of art.

Born 1942, Espanola, New Mexico
California State University, Los Angeles, BA, 1964
California State University, Los Angeles, MA, 1969

Sandoval lives in Lexington, Kentucky, where he is a Full Professor at the University of Kentucky, Lexington.

Pattern Fusion No. 1
2004
Recycled Mylar and 35 mm microfilm, netting, monofilament, thread, plaited braid, Pellon, polymer medium (machine stitched and interlaced; fabric backed)

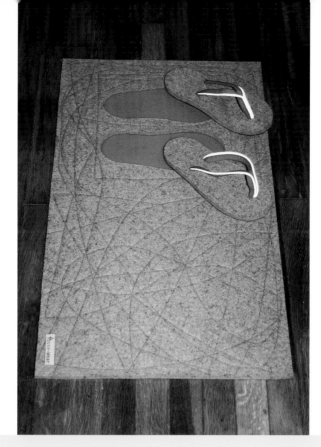

Slipper Mat
Designed 2006; released 2007
Wool, felt, reflective vinyl

Laura Sansone Cranbrook Academy of Art, MFA, 1994

With footwear embedded directly into Laura Sansone's *Slipper Mat*, the product cleverly calls our attention to conventions of domesticity and our love for convenience. As the work is put into use it provokes awareness of an unusual relationship between feet, floor and living space. A wittily conceived design, the mat is no longer the place where one leaves one's shoes, but the place of their origin and repose.

Born 1968, Huntington, New York
University of the Arts, Philadelphia, Pennsylvania, BFA, 1990

Sansone lives in Highland, New York, where she is a designer for House-Wear. She also is an Adjunct Faculty member at Maryland Institute College of Art, Baltimore, and for Parsons The New School of Design in New York City.

Liz Sargent Cranbrook Academy of Art, MFA, 2002

The concept of fraying takes on new meaning in Liz Sargent's *Striae*, a sculptural installation that features the partial deconstruction of two modern chairs covered by the long woolly threads of their own upholstery. In this work and in her new work for *Hot House*, Sargent explores both the fragility and endurance of fabric and evokes the histories and evolution of furniture. At the same time, she wryly generates new forms in the ongoing life of these objects.

Born 1964, Fort Worth, Texas
East Carolina University, Greenville, North Carolina, BFA, 1989

Liz Sargent lives in Savannah, Georgia, where she is a Professor of Fiber at the Savannah College of Art and Design.

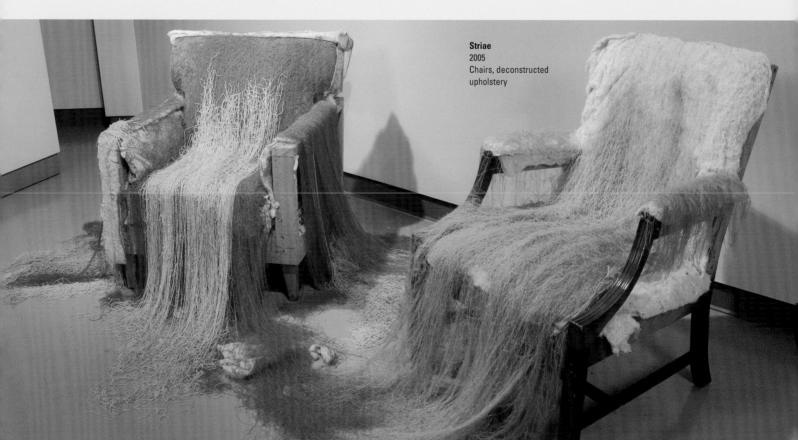

Striae
2005
Chairs, deconstructed upholstery

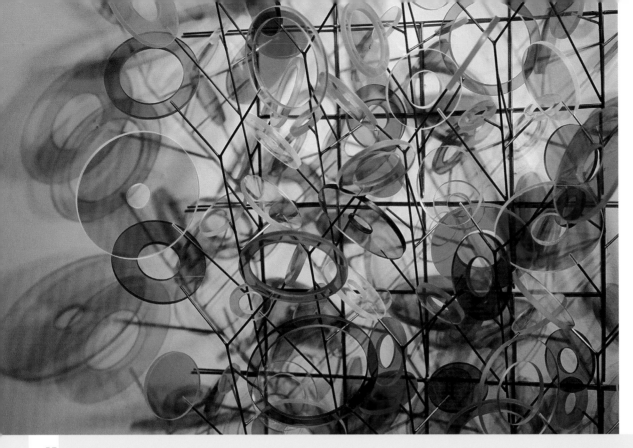

Shadowfield/Colored Light
2007
Polycarbonate, stainless
steel brackets, silver braze

Warren Seelig Cranbrook Academy of Art, MFA, 1974

Warren Seelig's *Shadowfield/Colored Light* is an example of what the artist describes as "a metaphorical textile," which evokes fundamental sensations rooted in textile experiences. With a field of objects on a stainless steel grid, the work extends from the wall, appearing to hover. In the gravity-defying interactions between shapes and their projected shadows, color and rhythm, a new fabric of energy, light and motion is formed.

Born 1946, Abington, Pennsylvania
Philadelphia College of Textiles & Science,
BFA, 1972

Seeling lives in Rockland, Maine.
He is a faculty member at the Maine
College of Art in Portland, Maine, and a
Distinguished Visiting Professor at the
University of the Arts in Philadelphia.

Anne Selden Cranbrook Academy of Art, MFA, 2005

Clothing designer Anne Selden takes inspiration from the architectural designs of Zaha Hadid and Diller Scofidio + Renfro, and the construction techniques of clothing designers Cristobal Balenciaga, Madeleine Vionnet, and Yohji Yamamoto, especially their skilled manipulation of seam lines and pattern shapes to form garments. *Exterior* and *Interior,* also in *Hot House,* combine Selden's interest in architectural structure with clothing design and consider the relationship between the inside/private and outside/public spaces of a garment to the wearer and the audience.

Born 1980, Petoskey, Michigan
Washington University,
St. Louis, Missouri, BFA, 2002

Selden lives in St. Paul, Minnesota, and is
the owner of Sartoria LLC in Minneapolis,
Minnesota.

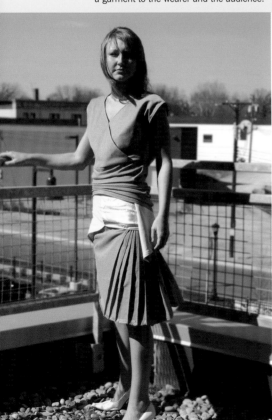
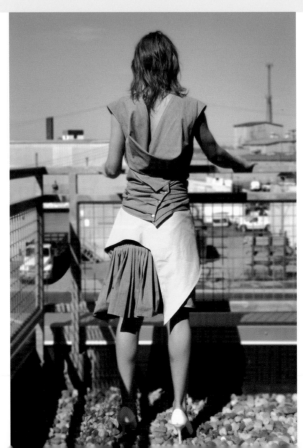

Exterior (Front and Back)
2007
Cotton, silk

White Wall and Screen
2001
White Wall: Hand-printed
polyester/cotton cloth, wood
Screen: Hand-cut muslin,
gesso, graphite, steel
armature

59

Piper Shepard Cranbrook Academy of Art, MFA, 1988

In *White Wall and Screen* by Piper Shepard, a scrim of translucent material serves as a diaphanous foil through which the observer may view a wall of darker filigreed hand-cut cloth. The parallel planes define a simple, minimal architectural space, and the materials quietly create the mood contained in that space.

Born 1962, Willimantic, Connecticut
Philadelphia College of Art, BFA, 1985

Shepard lives in Baltimore, Maryland, where she is a Professor in the Fiber Department of the Maryland Institute College of Art.

60

Sheri Simons Cranbrook Academy of Art, MFA, 1985

Sayonara is a kinetic work that consists of two large hanging circular structures made of balsa wood and basswood. Each component slowly rotates and one supports a model train with a white ruff that whizzes around its upper perimeter, causing it to sway under its weight. Accompanied by a slowed version of Gene Autry's "You Are My Sunshine," the narrowly averted sense of disaster evokes a hypnotic environment of flawed mechanics.

Born 1954, Detroit, Michigan
University of Michigan, Ann Arbor, BFA, 1979

Simons lives in Chico, California, where she is a Professor in the Department of Art at California State University, Chico.

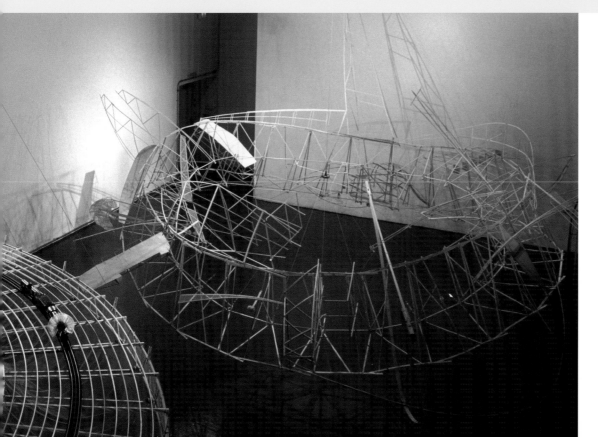

Sayonara
2002
Still from video

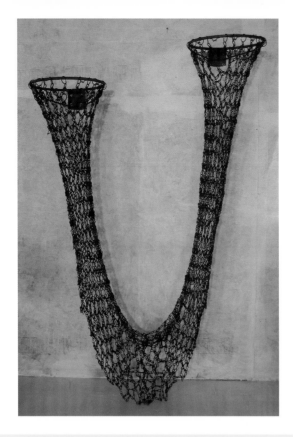

Flow
2003
Steel chain,
basketball hoops

Lucy Slivinski Cranbrook Academy of Art, MFA, 1984

Lucy Slivinski uses mundane materials, discards, and even industrial waste to build provocative sculptures in which the language of form extends or subverts the meaning of materials in unexpected ways. In *Flow*, the strength of steel chain is subverted as the material is used as a drawing device to define the passage between two basketball hoops forming a fictional but visually compelling relationship.

Born 1958, Chicago, Illinois
Northern Illinois University,
Dekalb, BFA, 1980

Slivinski lives in Chicago, Illinois.

Koo Kyung Sook Cranbrook Academy of Art, MFA, 1987

Koo Kyung Sook uses her own body to create figures that seem to float in a complex, textured matrix. Markings is a series of body imprints made by lying on hairy fabric soaked in developer over multiple sheets of photographic paper exposed to light, resulting in the unpredictable patterns that are scanned in life-size digital prints. The interaction of body, materials and light creates works that allude to the life cycle of human experience.

Born 1960, Seoul, South Korea
Hongik University, Seoul, South Korea, BFA, 1983
The School of the Art Institute of Chicago,
Illinois, BFA, 1985

Sook lives in Sacramento, California, and in Taejon, South Korea, where she is a Professor of Fine Arts at the Chungnam National University.

Markings No. 7-1 and **No. 7-2**
2007
Digital prints on mulberry paper

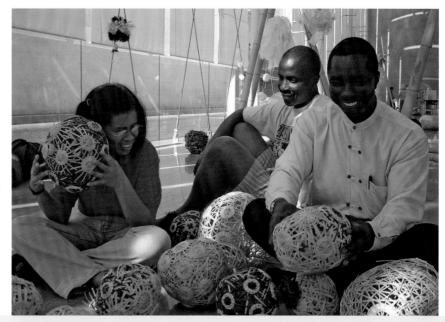

Shape of the Sound
1999, 2001, 2002, 2003 and 2005
(Summer and Fall)
Still from video

63

Kaori Takami Cranbrook Academy of Art, MFA, 1998

Art making as a social activity is fundamental to the work of Kaori Takami. Her Fiber Zero Association passes down the methods of traditional arts and crafts and combines contemporary technologies to creatively engage all the senses. Takami's *Shape of the Sound* project is an event that takes place in Japan and the United States in alternating years, and incorporates tactile and sound qualities in art pieces so that audiences of all abilities can interact with art.

Born 1967, Machida, Tokyo, Japan
St. Olaf, Northfield, Minnesota, BFA, 1991

Takami lives in Brooklyn, New York, where she is the founder and President of the non-profit corporation Fiber Zero Association (FIZA).

64

Katarina Weslien Cranbrook Academy of Art, MFA, 1980

Katarina Weslien has traveled extensively throughout Iran, India, Tibet and Indonesia, researching cloth and clothing as a cultural by-product of social identity. In this series of images taken in western Tibet, garments as offerings were photographed as they appeared in the funeral grounds on Mt. Kailash, a site sacred to Buddhists, Hindus and Jains as a place of renewal. For the artist, these images allude to global migration and human vulnerability.

Born 1952, Uppsala, Sweden
Utah State University, Logan, BFA, 1975

Weslien lives in Portland, Maine, where she is the Director of Graduate Studies and Associate Professor of Interdisciplinary Studio at the Maine College of Art.

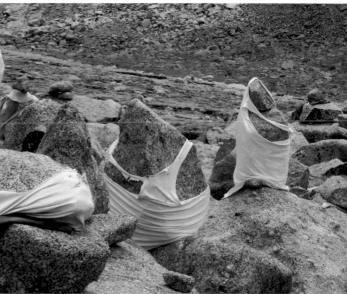

Untitled Clothing
2005
Iris prints

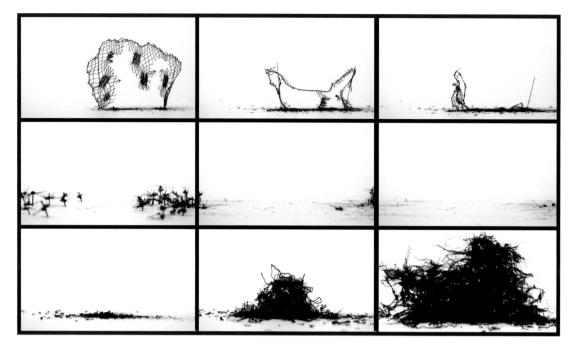

Errant Behaviors
2004
Stills from video and
sound installation

Anne Wilson (Artist)
Shawn Decker (Composer)
Cat Solen (Animator)
Daniel Torrente (Post-production
Animator and Mastering)

65

Anne Wilson Cranbrook Academy of Art, BFA, 1972

Anne Wilson's *Errant Behaviors* is a video and sound installation employing lace fragments, thread and insect pins and is comprised of two DVD projections and two stereo soundtracks. Both humorous and dark, the animated narrative evokes anthropomorphic action, quirky cityscapes, and post-apocalyptic worlds. Each of the twelve segments on DVD1 was conceived to play in relationship to the eleven segments on DVD2 in a shuffled order, allowing ongoing improvisational relationships to occur and incidents to accumulate.

Born 1949, Detroit, Michigan
California College of the Arts,
Oakland, MFA, 1976

Wilson lives in Evanston, Illinois, and is a Professor and Chair of the Department of Fiber and Material Studies at The School of the Art Institute of Chicago.

66

Seth Winner Cranbrook Academy of Art, MFA, 1997

Studio Z creates original designs for the furniture industry and textile suppliers with an emphasis on environmental sustainability. Panda pillows are made with Studio Z's innovative JacqForm process, which uses the jacquard loom to weave a double cloth structure producing two fabrics, one on top of the other, but joined together along the outline of each panda. After weaving is complete, each panda may be cut from the fabric panel and stuffed, requiring only minimal sewing.

Born 1970, Harrisburg, Pennsylvania
University of the Arts, Philadelphia,
Pennsylvania, BFA, 1992

Winner lives in Grand Rapids, Michigan, where he is a textile designer for Studio Z.

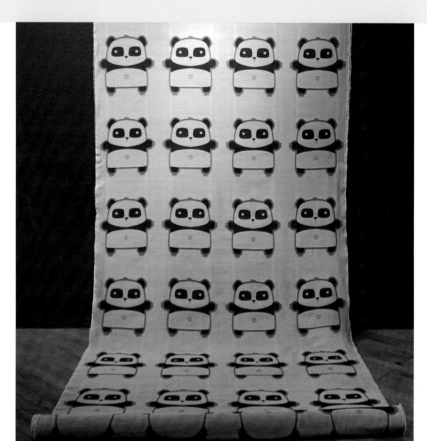

JacqForm Pandas
2007
Recycled polyester, natural cotton fill
(jacquard weave)

Seth Winner (Textile Development)
Studio Z Textiles LLC (Manufacturer)
Scott Lewis (Graphic Design)
Anna Zaharakos (JacqForm Concept and
Studio Z Founder)

Bhakti Ziek Cranbrook Academy of Art, MFA, 1989

Artists are frequently asked to offer a written statement of purpose or intention to accompany their visual work. In *Artist's Statement*, Bhakti Ziek creatively fuses the textile with the statement, narrowing the distance between the two while reflecting on the evolution of her practice. The jacquard loom makes possible the intricate labor of selecting threads one by one to embed the message in the matrix of woven cloth.

Born 1946, New York, New York
State University of New York at
Stony Brook, BA, 1968
University of Kansas, Lawrence, BFA, 1980

Ziek lives in Cerrillos, New Mexico.

least I can look at it--and then I know. And I can say, not this. Every not this gets me closer to the yes. What ever that is.

In the mid-80's I was in New York again. While defining myself as a fiber artist, I did a stint in the textile industry. It was another world view of textiles that I had not encountered before, and it was quite mysterious to me. In this world, all my previous textile experiences counted as nothing. Out of frustration of not understanding, out of curiosity, and just for fun, I began to go to the F.I.T. Swatch Library. Feverishly I would study old fabrics for their weave structure and design.

During graduate school I took the path of narrative. It was a wonderful time. I learned to look at my life, and my personal experiences, and use them in my work. To generalize from me as the individual to the all-encompassing we. I wove literal images--not photo realism but identifiable. The cellist was clearly a cellist. I enjoyed a process of working that I had envied in others. I knew my characters. I told myself elaborate stories as I wove, and I wove more elaborate ones with words afterwards as I looked at the work. I received excellent publicity and found myself writing and talking about the work, and about narrative work as an art form. I built this neat box. And then I realized that I didn't want to work this way any more, that in fact, even as I was writing and talking, my weaving was moving again into an abstract realm.

This building of boxes, or identities, and then the Houdini-like movements of extracting myself from these enclosures seems to be part of my path. I am learning to temper my words and my enthusiasm. To recognize that I do talk from my heart, from a place of honesty and truth--but to

Artist's Statement
1994
Cotton, double cloth
(jacquard weave)

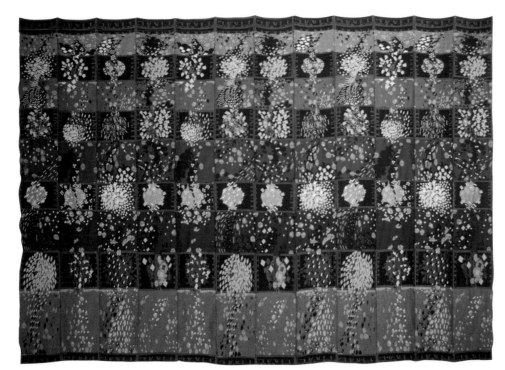

Time After Time
1995
cotton and metallic yarns
(jacquard weave)

Gerhardt Knodel

Artist-in-Residence and Head of the Fiber Department, 1970–1996
Cranbrook Academy of Art, Director, 1995–2007

Born 1940, Milwaukee, Wisconsin
University of California, Los Angeles, BFA, 1961
California State University, Long Beach, MFA, 1970

Gerhardt Knodel consistently has explored the potential for textiles to be integrated with contemporary experience. *Hot House* presents four of these works. *Act 8* explores the textile's ability to soften one's living environment and to reshape it with a simple gesture suspended in space. The lightness and movement of the fabric define space in a way that contrasts with hard surfaces and inspire the occupant to consider expressive associations. *Guardians of the New Life* presents human figures occupying the two-dimensional space of a woven textile, a "place" that is very different from the space of an illusionistic painting. Decorative associations are juxtaposed with the figures to initiate further reflections on their relationships. *Time After Time*, originally designed as a bed cover, is based in the familiar format of *Time* magazine covers, replacing the usual portrait with an abstract visualization of time in space. *By Coincidence: Yellow/Black* is an embodiment of travel experiences with the Fiber Department in 1995, a provocative interface between Cranbrook England and Cranbrook Michigan.

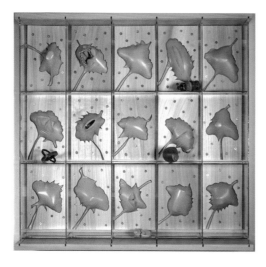 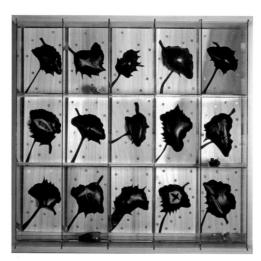

By Coincidence: Yellow/Black
1995
Wood, glass, plastic, rubber foam, small objects

Act 8
1974
Silk, nylon cords

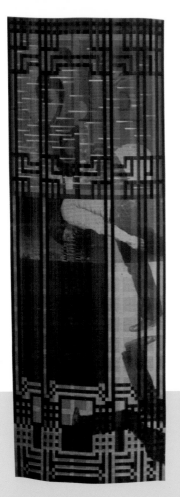
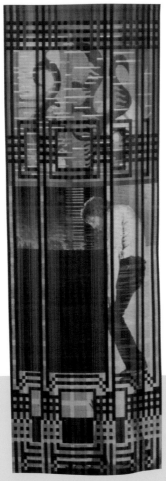
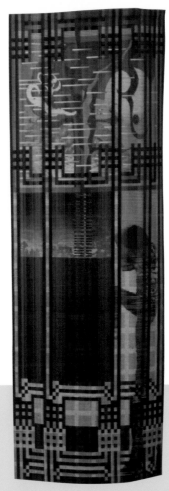

Guardians of the New Life
1987
Cotton, linen, Mylar, rayon, metallic gimp

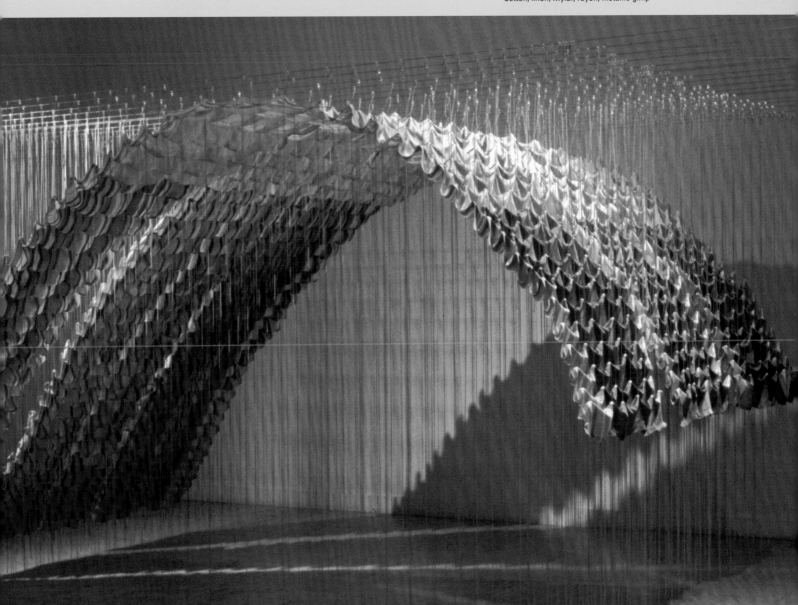

Cranbrook Academy of Art, MFA, 1979
Artist-in-Residence and Head of the Fiber Department, 1997–2007

Born 1948, Chattanooga, Tennessee
California College of the Arts, BFA, 1974

Jane Lackey

Jane Lackey's *panorama*, a translucent drawing with twenty-one components, forms a continuous grid that reads as a complex, scientific string. Such genetic mapping and sequencing are at the forefront of much of Lackey's artistic investigation and parallel the contemporary ambitious attempts to harness the vulnerable and elemental forms of nature. In *panorama*'s near infinite complexity, we discover associations that are reassuring and serendipitous as she applies similar scrutiny to the gene pools of a specific community.

Lackey finds parallels in language and genetics, fields that use letters to record the order of their elemental parts. In *SNPs/slips*, SNPs (pronounced snips) are unexpected genetic sequences whereas "slips" references verbal miscues. To present her investigation of these phenomena, Lackey has taken apart and rejoined dictionaries to reveal unexpected variations. The result is an intimate combination of imagery, poetry, humor and scientific allusion.

panorama (18) (detail)

panorama (1-21) (detail of installation)
2005
Tape, thread and paint on paper mounted on
white lacquered board

SNPs/slips (detail of installation view of twelve works)
2002-2003
Dictionaries, laser engraving, lacquered wood frames

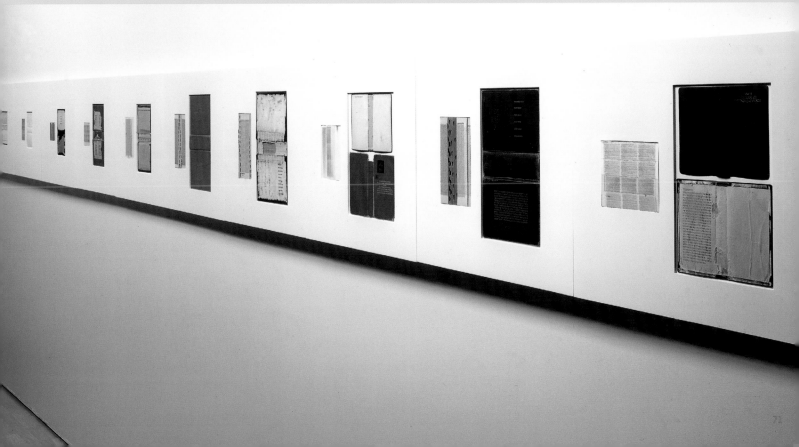

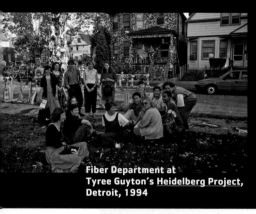

Fiber Department at Tyree Guyton's <u>Heidelberg Project</u>, Detroit, 1994

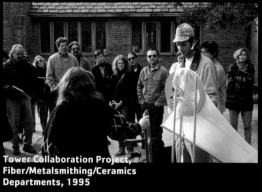

Tower Collaboration Project, Fiber/Metalsmithing/Ceramics Departments, 1995

Fiber Department Students in Bathroom of Govinda's Restaurant, Fisher Mansion, Detroit, 1991

Animus, Jong Sook Moon, 1993

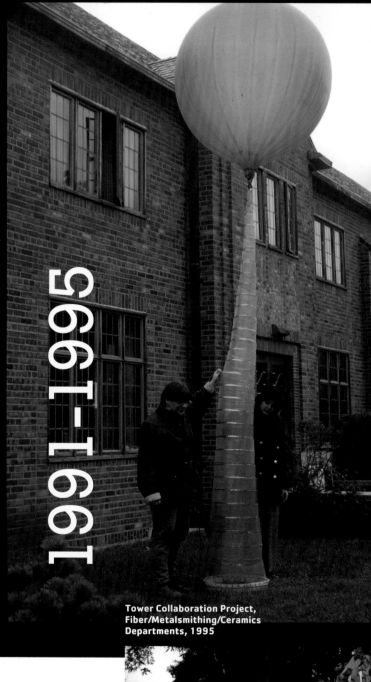

1991-1995

Tower Collaboration Project, Fiber/Metalsmithing/Ceramics Departments, 1995

Fiber Reunion, Cranbrook, July 1992

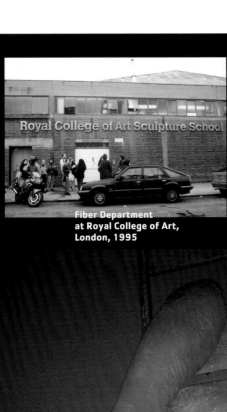

Fiber Department
at Royal College of Art,
London, 1995

First Academy of Art
Director's Day, 1995

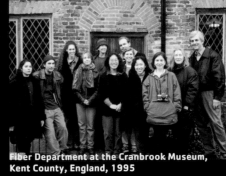

Fiber Department at the Cranbrook Museum,
Kent County, England, 1995

Cranbrook Collaborative
Project in Pontiac, 1995

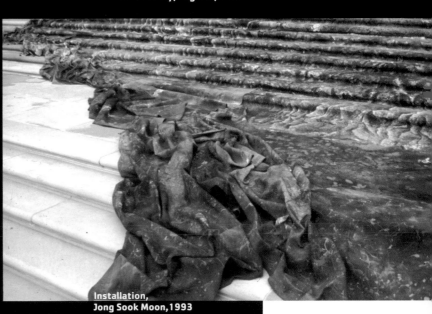

Installation,
Jong Sook Moon, 1993

Tower Collaboration Project, Fiber/
Metalsmithing/Ceramics Departments, 1995

Products of the Adventure

As anyone who has visited, much less studied there, will be prepared to tell you, Cranbrook Academy of Art is a curious place. When you walk around the campus, marveling at the visionary 1930s architecture of Eliel Saarinen, you feel that Cranbrook is like nowhere on earth. But strangely, when you leave, you are constantly reminded of the place wherever you go. In creative fields ranging from architecture and design to the fine arts and studio crafts, the school's influence ranges across America and further abroad.

Cranbrook Fiber in Context /
Glenn Adamson

[1] For more on the early history of fiber and other media at the school, see Cranbrook Weavers: Pacesetters and Prototypes (Detroit: Detroit Institute of Arts, 1973); and Robert J. Clark, et al., Design In America: The Cranbrook Vision, 1925–1950 (New York: Harry N Abrams, 1984).

[2] On Rossbach, see the author's own "The Fiber Game," Textile vol. 5, issue 2 (Summer 2007).

This asymmetry seems typical of Cranbrook's very particular character. It is simultaneously a small, protected environment —a modern, if not quite *echt*-modernist, Utopia— and a community of cosmopolitan extroverts: an ivory tower with global ambition. Its graduates may be hothouse flowers, but when they go out into the world, they seem unfailingly to turn it on its ear.

This is as true in the field of fiber art as any of the disciplines in which Cranbrook provides instruction. It is easier to catalogue than to explain the institution's impact on the field. The Academy has produced graduates of tremendous variety and outstanding significance for many decades, beginning with the establishment of a weaving department under Loja Saarinen in 1929 and continuing under the leadership of Marianne Strengell (from 1942 to 1961) and Glen Kaufman (from 1961 to 1967).[1] Just after World War II, the school graduated two students who marked the extremes of fiber art's ambitions. Jack Lenor Larsen was the first of these, an explosively creative industrial designer of fabrics who also had a sideline in the promotion of swaggering, heroic fiber sculpture. The other was Ed Rossbach, a modest but cross-grained basketmaker who became the fiber field's conscience and guiding spirit.[2] That two men of such opposing character could find exactly what they needed at Cranbrook says a lot. It suggests that even at this early date, the school was more about fostering individuality than instilling a doctrine.

Certainly, this focus on individual expression would become the signature feature of the fiber program at Cranbrook under Gerhardt Knodel, who in 1970 took the helm of what was then the Fabric Design program. In an early departmental précis Knodel noted:

[3]Mildred Constantine and Jack Lenor Larsen, Wall Hangings (New York: Museum of Modern Art, 1969).

[4]Jack Lenor Larsen and Mildred Constantine, ed., The Art Fabric: Mainstream (New York: Van Nostrand Reinhold, 1981). For a perceptive review of this book and exhibition (singling out Knodel's work Act 8 as "the most spectacular piece [and] certainly the one receiving the most enthusiastic comment"), see Peter Selz, "Knots & Bolts," Art in America vol. 70, no. 2 (February 1982): 107–115. For an evaluation of Constantine and Larsen's early projects see Elissa Auther, "Classification and Its Consequences: The Case of 'Fiber Art,'" American Art vol. 16, no. 3 (Autumn 2002): 2–9.

The past decade has evidenced unparalleled growth in the use of fibers and fabrics. With the world's vast heritage of fiber objects providing fundamental support, the contemporary craftsman has moved forward adventurously. The results must be viewed as products of the adventure... The most vital experience to be gained by any student is understanding of self in the context of today's world.

In this brief statement of his teaching philosophy, Knodel managed to circumscribe the recent past of his field, and to predict a future that, indeed, has come to pass in the decades since. In the early 1970s, fiber art seemed to be on the brink of a momentous breakthrough led by the Polish artist Magdalena Abakanowicz and the American expatriate Sheila Hicks. Along with an impressively international coterie of fellow weavers-cum-installation artists (such as the Colombian weaver Olga de Amaral, who trained at Cranbrook in the early 1950s), Abakanowicz and Hicks pulled off a series of alternately heroic and conceptual installations that is probably unequalled in the history of postwar studio craft. The first Americans to recognize the significance of this trend were Ruth Kaufmann, gallerist and author of the 1968 book The New American Tapestry; the Museum of Contemporary Crafts curator Paul Smith, who organized the exhibition Woven Forms in 1963; and Cranbrook's own Jack Lenor Larsen. With Mildred Constantine, Larsen curated a seminal international survey exhibition at the Museum of Modern Art entitled Wall Hangings (1969), and went on to co-author with Constantine a series of lavishly illustrated books on the new fiber art.[3]

A major preoccupation of this activity was (as the title of a 1981 Larsen and Constantine exhibition project pronounced) the objective of inserting fiber art into the contemporary art "mainstream."[4] As Knodel's essay in this volume recounts, he himself was strongly committed to this goal of acceptance for the medium of fiber. His own practice and pedagogy, however, were anything but slavishly devoted to modish contemporary art. Indeed, much of his teaching was directly inspired by the examples of architecture on the one hand, and on the other by a world history of textiles —weavings from Latin America, knotted baskets from Africa, and dye techniques from Southeast Asia— about which artists working in other media have remained mostly ignorant.

By contrast, partly for budgetary reasons, but mainly because of the disposition of the program, Cranbrook has not necessarily been at the forefront of the technology wave in textile production. This is not to say, however, that Knodel himself or the students within the program have not been interested in and sympathetic to the claims made for technology's impact on textiles. These have ranged from early, futuristic predictions —like Jack Lenor Larsen's hope (sadly unrealized)

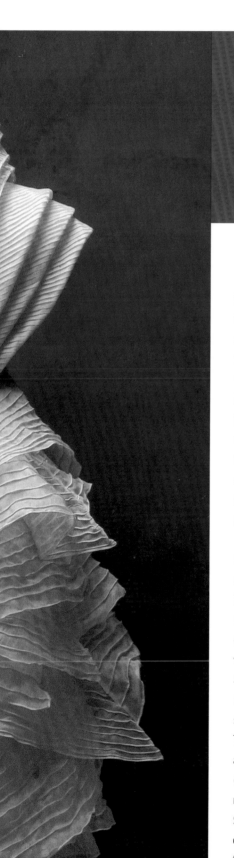

[5] Retrospective: Jack Lenor Larsen (Fort Wayne, Indiana: Fort Wayne Art Institute, 1969), n.p. For an overview of Jefferies's work and writing see Victoria Mitchell, ed., Selvedges: Janis Jefferies: Writings and Artworks Since 1980 (Norwich, UK: Norwich Gallery, 2000).

[6] See Matilda McQuaid, Extreme Textiles: Designing for High Performance (New York: Princeton Architectural Press, 2005); Matilda McQuaid, Structure and Surface: Contemporary Japanese Textiles (New York: Museum of Modern Art, 1998).

[7] Gerhardt Knodel in conversation with the author, March 7, 2007.

[8] On The Fabric Workshop see Marion Boulton Stroud, et al., New Material as New Media: The Fabric Workshop and Museum (Cambridge, Massachusetts: MIT Press, 2002).

that "spraying on a flexible, disposable cocoon may one day be part of the toilette"[5]– to British weaver Janis Jefferies's Poststructuralist writings, which present fabric in somewhat arcane terms as an ideal aesthetic mirror to the interwoven and networked postmodern society. Like most involved in fiber arts, the artists of the Academy have taken a keen interest in the "extreme textiles," as described by curator Matilda McQuaid, and the technical innovations that have been pioneered by the Japanese designer and weaver Junichi Arai (who might be considered the direct descendant of Larsen).[6] They also look outside the parameters of the studio environment, turning to fabricators and industry in order to produce work when necessary. But it is equally likely that students might choose to define their works consciously in opposition to advanced technology. This is part of the Academy's open space of experiment, in which students choose or devise their own tools: "a theater," as Knodel puts it, "a place to stage possibilities and see them played out."[7]

In many ways the best institutional parallel to Cranbrook in the 1980s is not another higher educational institution, but rather an equally experimental, uncategorizable place: The Fabric Workshop in Philadelphia. Founded in 1977 by Marion Boulton Stroud, the history of the Workshop reads like the history of Cranbrook fiber in miniature: an initial phase of commitment to the ideal of working with industry, yielding (rather more swiftly than Cranbrook) to a much more ecumenical vision in which resident artists do as they like with the organization and its facilities. Though Stroud claims to harbor a residual dislike for installation art and a continuing fond wish that artists might commit themselves to designing repeat yardage of a radical type, in fact the institution's success has mainly been the result of its tolerance of individual creativity. The guest list at The Fabric Workshop, again not unlike that at Cranbrook, has included both obvious choices, such as artists associated with the brief and humid Pattern and Decoration Movement of the 1970s (Kim McConnel) and those who already worked with fabric and textiles (Faith Ringgold), and more surprising figures such as Carrie Mae Weems, Mona Hatoum, and the architects Venturi, Scott Brown, and Associates.[8] In some respects, The Fabric Workshop has pursued a course opposite to that of Cranbrook's fiber program —bringing a conversation about art to fabric, rather than the other way round— but it is not surprising that the two institutions have crossed in the

[9]Gerhardt Knodel in conversation with the author, March 7, 2007. On the Holly Solomon Gallery see Richard Armstrong, "A Short History of the Holly Solomon Gallery," Holly Solomon Gallery Inaugural Exhibition, catalogue (New York: Holly Solomon Gallery, 1983); and Alexandra Anderson–Spivy, Robert Kushner (New York: Hudson Hills Press, 1997).

[10]This link was first made by fiber art's own supporters, as in Dona Meilach's book Macramé: Creative Design In Knotting (New York: Crown Publishers, 1971), a how–to guide that also included an overview of the work of leading off–loom knotters such as the Swiss artist Françoise Grossen, and the Americans Claire Zeisler and Walter Nottingham.

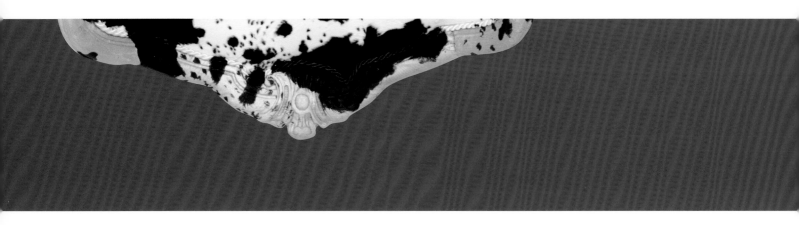

middle. Certainly the ties between them have been close ones. Both Stroud and Knodel found early inspiration at the Holly Solomon Gallery, the main promoter of Pattern and Decoration art; Stroud visited Bloomfield Hills in 1976 while developing her plans, looking for a model to follow; and Cranbrook students have in turn routinely gone to The Fabric Workshop to **work as interns.**[9]

This like-mindedness is interesting in that it consists not of a shared set of objectives, but rather an open attitude with respect to the collision between textiles and artistic inquiry. Certainly, this has been the most successful model for any undertaking in the textile arts in recent years. Fiber art's moment of ascendancy had collapsed into a derisive dismissal of anything hand-knotted as an uppity version of that hippie staple, **macramé.**[10] Some textile-based institutions, such as the Lausanne Biennals, have fallen by the wayside because of their commitment to heroic fiber art and their inability to cope with other (sometimes actively critical) possibilities. By the end of the 1980s, the most important figure of the fiber art boom, Abakanowicz, had left tapestry behind in favor of cast bronze sculpture. Larsen and Constantine's 1969 exhibition at the Museum of Modern Art seems a distant memory.

Meanwhile, though, the Cranbrook way of doing things has flourished, in large part thanks to the success of its graduates as educators, as well as artists. The Fiber and Material Studies Department at the Art Institute of Chicago, the largest program in the field, is led by two Cranbrook graduates, Anne Wilson and Joan Livingstone; other former students lead programs at the Maryland Institute of Arts (Annet Couwenberg and Piper Shepard); University of Wisconsin-Milwaukee (Kyoung Ae Cho); University of the Arts, Philadelphia (Warren Seelig and Mi-Kyoung Lee); University of Kentucky (Arturo Alonzo Sandoval); Maine College of Art (Katarina Weslien); Moore College of Art and Design (Michael Olszewski); and elsewhere. There are also strong connections between the Academy and the Kansas City Art Institute, where Cranbrook's current head of the Fiber Department, Jane Lackey, taught previously. Cranbrook itself continues to be a powerhouse in the arena of "fiber art," even as that term has increasingly come to seem a historical reference point rather than a going concern. As at most art schools in America and Britain, there has been a post-disciplinary turn at the Academy. Individual departments remained fairly compartmentalized until the 1990s, but those days are long gone. Now faculty and students actively seek collaboration across departmental lines, with the result that graduates have been cross-trained to an unprecedented degree.

[11]Jane Lackey, letter to the author, April 4, 2007.

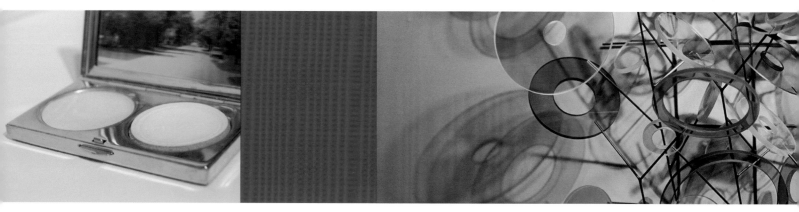

The potential danger that such an approach entails is clear: an erosion of the skill base that craft programs have traditionally instilled. The broader climate certainly suffers from this fault. To take only one obvious example, the needlework of the mega-successful British artist Tracey Emin bears the clear signs of a lack of formal control —ranging from a lovable, homey ineptness in her early quilts and famous appliquéd tent, *Everyone I Have Ever Slept With, 1963-1995* (1995), to a certain slickness in more recent works, the sewing of which Emin has delegated to professionally skilled assistants. Needless to say, however, this casual approach to production is nowhere to be seen in the work gathered for the *Hot House* exhibition. Cranbrook seems to be having its cake and eating it too. Its students continue to have a sound understanding of their own way of making, but also an increasingly sophisticated grasp of the proposition-based art that has become the norm in contemporary art.

An exhibition staged by the department under Lackey's leadership in 2006, *With What We Can Carry*, serves as an apposite concluding indication of the direction of Cranbrook fiber. For this project, in true Conceptualist style, each participant was required to obey certain rules, such as "the artist should be able to carry the work for one mile or more" and "no extra packaging can be used: the piece protects itself." The results, like those in the present exhibition, were impressively varied —ranging from what Lackey calls an "inflatable monster" made of used shirts to a delicate wall-hung piece fashioned from cigarette papers, which could be folded up for purposes of easy transport. Lackey herself executed a large-scale drawing that could be folded up **like a map.**[11] At the opening of the exhibition, rather than placing it in a static display, she simply unfolded the work and showed it to anyone who was interested —a gesture that seems entirely of a piece with the wildly creative but fundamentally other-directed teaching style that has always been the rule at Cranbrook. Returning to the list of rules that guided *With What We Can Carry*, we find a last phrase that might serve as the continuing motto for fiber at this extraordinary institution, a rule that cuts against all other restrictions, and cheekily restates the Knodel doctrine of individuality: "All these requirements should be considered carefully, and can be consciously defied."

Dr. Glenn Adamson is Head of Graduate Studies and Deputy Head of Research at the Victoria & Albert Museum, London, where he leads a graduate program in the History of Design. He was previously Curator at the Chipstone Foundation, Milwaukee, and in that capacity prepared exhibitions at the Milwaukee Art Museum and taught at the University of Wisconsin-Madison.

Erin Miller Wearing
"Jill Stoll Original" Sweater, 1997

Fiber and Metalsmithing
Departments in Istanbul, 1999

Moron and Maniac, Bora Kim, 1999

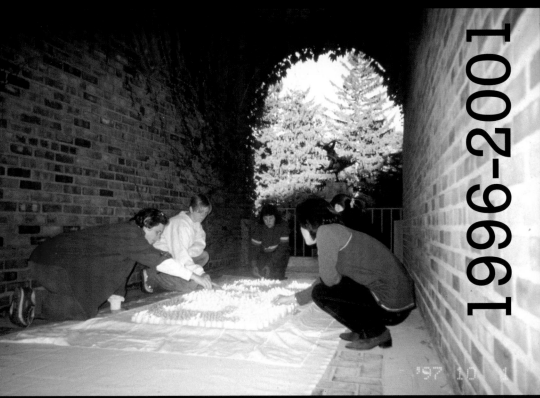

1996-2001

'97 10 4

Candle Lighting for Mi-Kyoung Lee's
Collaborative Installation, 1997

<u>Nobody at Home</u> Performance/Installation,
Yael Davids, <u>Skin</u> Exhibition, Cranbrook Art
Museum, 2000

Vanessa Kamp and Eeko Oniki with
Kamp's Suspended Sculpture, 1999

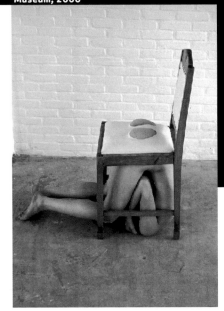

Guy Fawkes Ball,
Cranbrook Art Museum,
November 1996

T-Shirt Project,
Kaori Takami, Madrid, 1997

My Own Little World Performance,
Leesa Haapapuro, 1998

SKIN

Skin Exhibition,
Cranbrook Art Museum, 2000

Standard Brace Co.
No. 102 (In Use),
Maryann Lipaj, 2001

Pointing the Finger, Dorothy Cross,
Skin Exhibition,
Cranbrook Art Museum, 2000

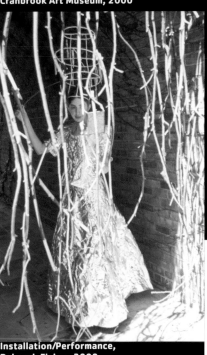

Installation/Performance,
Deborah Fisher, 2000

Fiber Department with
Architecture Alumna Gloria Cervantes
in Barcelona, 1997

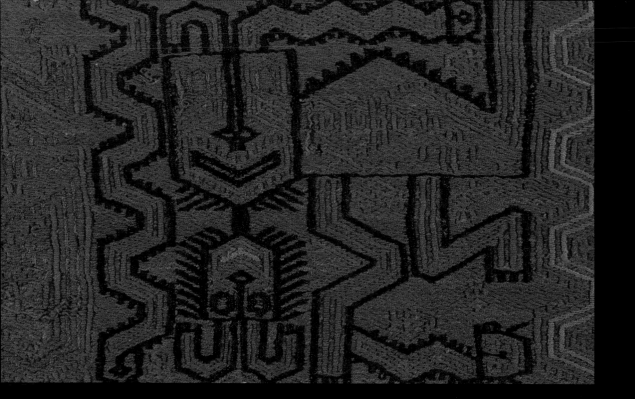

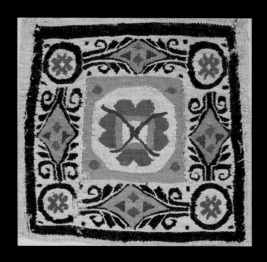

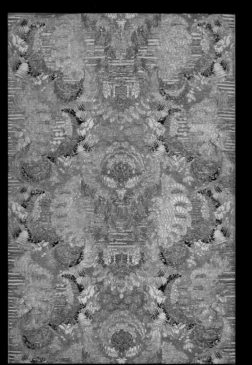

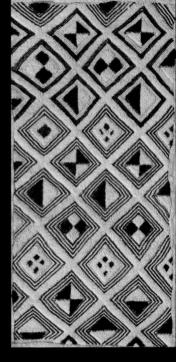

A Few **Fine Textiles**

**The Textile Collection of
Cranbrook Art Museum, 1927–2007 /** Rebecca Elliot

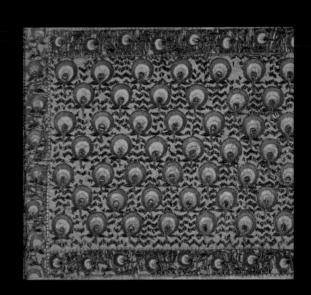

"Aside from the printed word and picture, the student
wants to see for himself at least a few typical examples
of the period —let us say, a chair, a table, a carved
chest, a piece of silver or ivory, and a few fine textiles."

More than just "a few fine textiles,"

Cranbrook Art Museum's collection has grown to include approximately one thousand examples —a fifth of the museum's entire art collection— and ranges in date from the first to the late twentieth century. They come from every corner of the earth —from the tropical islands of the South Pacific, the mountains of India, the deserts of Egypt, and the moors of England. These textiles, many of them fragments, have participated in Catholic church services in Renaissance Italy, have served as burial shrouds in pre-Conquest Peru, and have clothed the wealthy and adorned their houses in pre-Revolutionary France. Each piece has a story to tell about why it was made, who originally used it, and why it was saved. But there is another story to the textile collection, a story about its afterlife at Cranbrook Art Museum. How did it come to reside at the museum, and how has it been used since its arrival? Given George Booth's intentions, how have these textiles related to the activities of the Fiber Department of Cranbrook Academy of Art?

From its origin in 1927 with Booth's first purchases, Cranbrook's textile collection was an integral component of George Booth's overall vision for the institutions he founded at Cranbrook to educate young people and especially artists. By the late 1920s, Booth and Eliel Saarinen (the Finnish-American architect Booth selected to give form to his vision) had begun developing an organization that would promote the creation and appreciation of good design in both the fine and decorative arts. The idea first took form as the Arts and Crafts Studios that opened in 1929, then evolved into the Academy of Art that opened in 1932. Motivated by his belief in students' need for direct study of works of art, Booth assembled a study collection that corresponded to the media that would be taught in the school —painting, sculpture, architecture, metalworking, bookbinding, ceramics and textiles— along with a library of art books. The museum and library opened in 1930 to students as well as the public.

Booth sought to build a small, selective, yet encyclopedic collection that tended more toward historic rather than contemporary work. After all, the Cranbrook campus itself was being designed and furnished by contemporary artists, thanks to Booth's patronage, so this was not the area of greatest need for the museum. Thus, the nucleus of the textile study collection was a group of five hundred Italian and Spanish textile fragments dating from the fifteenth to the eighteenth centuries that Booth bought from a dealer based in Florence, Italy, in 1927. From that year until 1944, Booth acquired for the Art Museum approximately two hundred additional textiles from pre-Conquest Peru, China, India,

[1] George Booth to Florence Davies, "St. Martin Smiles." Detroit News, n.d. (Winter 1930), Cranbrook Academy of Art Library, CAM clippings. Booth was explaining the purpose of the Art Museum on the occasion of its opening. For a detailed account of the history of the Art Museum see Gregory Wittkopp, "Challenges and Opportunities: The Evolving Mission of Cranbrook Art Museum," in Cranbrook Art Museum: 100 Treasures (Cranbrook Art Museum, 2004), 10–28.